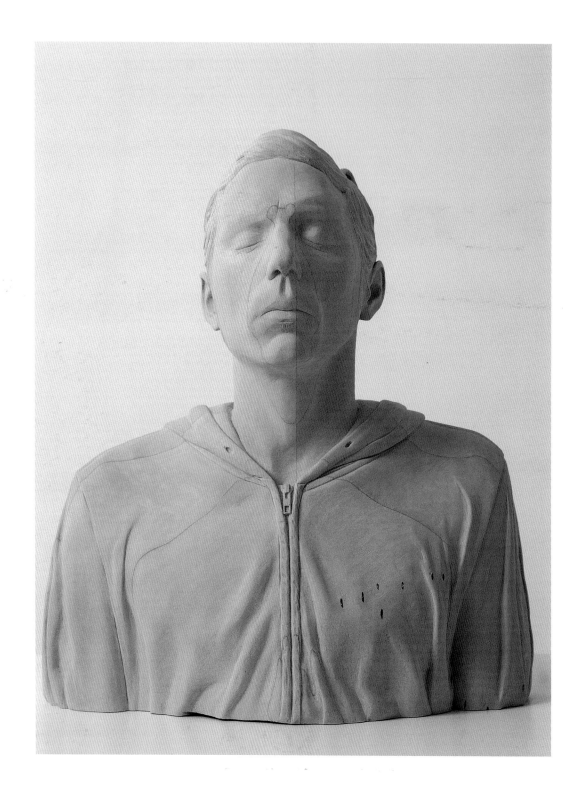

RICKY SWALLOW

FIELD RECORDINGS • JUSTIN PATON

New Art Series Editor: Ashley Crawford

CRAFTSMAN HOUSE

First published in Australia in 2004 by Craftsman House
An imprint of Thames and Hudson (Australia) Pty Ltd
Portside Business Park, Fishermans Bend, Victoria 3207
www.thamesandhudson.com

National Library of Australia Cataloguing-in-Publication data.

Paton, Justin
Ricky Swallow
ISBN 0 9751965 1 0
1. Ricky Swallow I. Title.
709.2

Editing: Bala Starr
Design: Terence Hogan
Production: Publishing Solutions Pty Ltd, Victoria, Australia
Printed in China

Author's Acknowledgments:
Thanks to the collectors, dealers and gallery staff, in particular Darren Knight of Darren Knight Gallery, who took time to show me works and share thoughts; to the Dunedin Public Art Gallery for granting some useful leave; and to the authors of earlier reviews and essays about Ricky Swallow's work, including Marah Braye, Edward Colless, Juliana Engberg, Bruce James and in particular Tom Nicholson. Terence Hogan for his elegant and conscientious design.
To Vita Cochran, more than thanks. – Justin Paton

Frontispiece:
And The Moment Will Come When Composure Returns (Decoy) 2002
laminated jelutong, 54.25 x 49.25 x 35.25 cm
Collection of Samuel and Shanit Schwartz, Los Angeles. Photo: Fredrik Nilsen

Australian Government

Australia Council for the Arts

This project has been assisted by the Australian Government through the Australia Council, its arts funding and advisory body.

CONTENTS

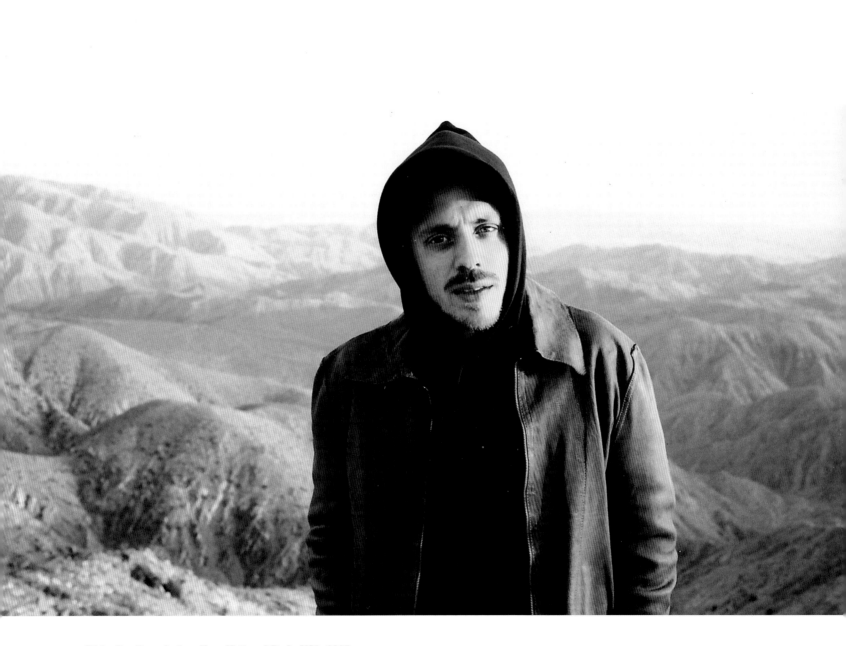

Ricky Swallow, Joshua Tree National Park, USA, 2003
Photo: Saskia Olde Wolbers

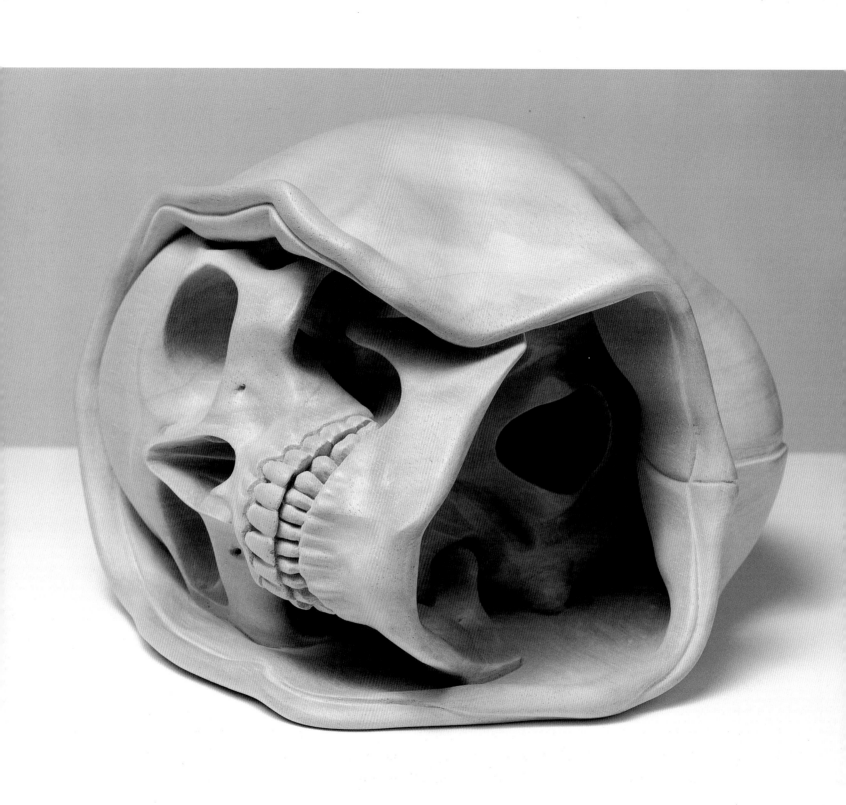

FIELD RECORDINGS

THIS VERY HOUR: THE WORK OF RICKY SWALLOW
By Justin Paton

In the small hours of a winter morning in Los Angeles in 2003, Ricky Swallow sat down with a belt-load of chisels and a block of hardwood, and started carving himself out of existence. Three weeks later the sculpture was finished. Swallow was long gone. *Everything is Nothing*, the object in question, is a portrait of the artist as a dead man. All that sets this skull apart from all the others in the world is a nick in its front tooth. It replicates a chip in Swallow's. All that pins the skull to our time is an adidas ski-hat. The skull wears it like a second skin.

Everything is Nothing began its life as a stump not much bigger than a football. It was strange to watch as the artist slowly worked toward his head with his hands. Early on, the object looked muffled and gnawed-at, as if fashioned by an impatient beaver. Swallow took back the wood with scoops and chisels, boring into its surface and creating chunky ridges and valleys. Then he brought out rasps and scrapers to reduce the ridges to scars, which in their turn got worn toward smoothness by sheet after sheet of sandpaper. From 320 grains per sheet to 600, then from 1000 to 1600, the advance through the wood grew slower. At some point carpentry became mani-cure, and the steady fall of chips and shavings slowed into occasional drifts of powder. There at last, its surface polished smooth as marble, was Ricky Swallow's grinning skull – toppled from its body, one ear to the ground, softly wrapped in its fabric helmet.

The sculpture puts us face-to-face with a paradox. Its emergence is also a disap-pearance. It gives absence an absolutely vivid presence. Less a producer than a reducer – an un-maker, a subtraction artist – Swallow has given time to the wood, and the result shows what time will take from him. Of course, every carving makes some-thing by taking something away, and every self-portrait is haunted by its maker's absence. But, by sculpting himself from the future's point of view, Swallow puts that absence at the heart of the matter. The result is a self-portrait, 'finished' in both senses, which seems to wait for the artist to catch up. In the meantime the object makes an

Facing page:
Everything is Nothing 2003
laminated jelutong, milliput
21.6 x 32 x 14 cm
Lindemann Collection, Miami Beach

irresistible offer to onlookers. The raised edge of the ski-hat is a sly, beckoning detail. As if gingerly lifted by an invisible finger, it invites queasy, contemplative inspection of the skull inside – its crenellations, fault-lines and crumple zones, the blade of its septum, the empty air of its orbits, and above all its lock-jawed grin. Through its wooden silence, this sculpture has something to tell us about the tests of time, the patience of objects, and the ratio of loss to gain.

But we are already getting ahead of the story. The story would begin, if we were to tell it conventionally, in Wonthaggi, which is where the man in the adidas ski-hat was born in 1974. He grew up in San Remo, a coastal town in the state of Victoria, Australia. The family hails, on his mother's side, from the island of Mauritius. His father was a shark fisherman, his grandfather something of a backyard *bricoleur*. Those who believe that art is a matter of simple autobiographical addition might put one and one together and point out that, at the time of writing, Swallow is carving a marine still life. But these origins and back-stories don't 'cause' the work; rather, they are part of the web of anecdotes and images that the work has brought into view. For all their narrative potential, Swallow's sculptures aren't stories in themselves so much as instruments for drawing stories and speculations from willing viewers. They are hints, and also promises, about what sculpture might be and do today.

Swallow is a small guy with a thin fringe of beard, a studio complexion, and a distance-runner's build. In conversation, he has a gift of mimicry, a way of talking about his work that's both loaded and laconic, and a modesty of manner that is a relief to encounter in an artist whose ascent has been rapid. To leaf through files of press on Swallow for the past few years is to hear a rising murmur of appreciation (the word 'wunderkind' comes up a lot) and anticipation. If you could run a soundtrack over this murmur it would be the noise of a studio in the small hours: the patter of woodchips, the creak of a chair, perhaps the whine of a street-cleaning machine outside, and whatever music Swallow happens to be measuring his time with at that moment. For there is a striking contrast between the intensity of the conversation that Swallow's work provokes and the rapt, quietist character of the work itself: its patience, its atmosphere of concentrated time, its radical commitment to detail.

We tend to associate detail with clarity, and conversely to think of blur and vagueness as the outward signs of mystery. In Swallow's art, however, detail is not an antidote to

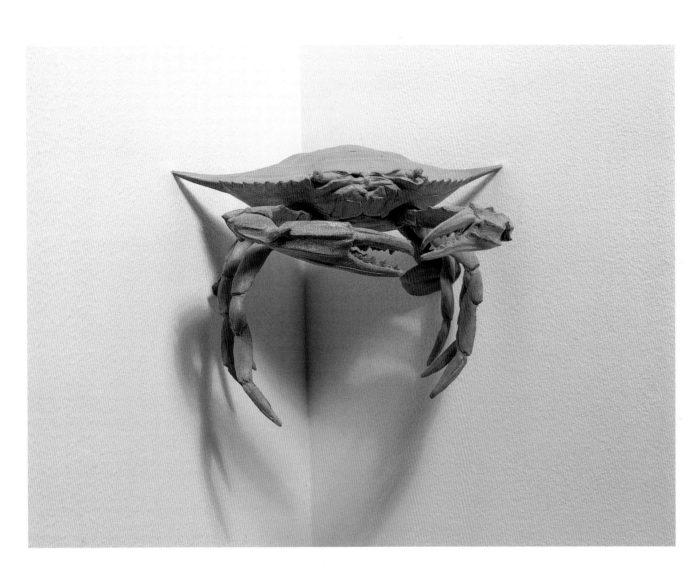

Minor Threat 2003
American walnut
12 x 6 x 8 cm

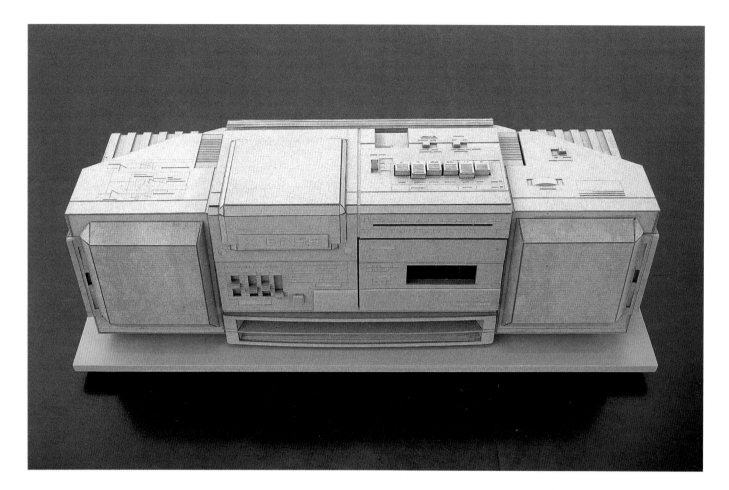

The X-Bass Woofer 1998
binders board, MDF
66 x 20 x 21 cm
Collection of Jim Barr and Mary Barr,
Wellington, New Zealand

mystery but a form of it – a way to delay recognition, to make strange, to enlarge an object in the viewer's mind. In a career that is not yet a decade long, Swallow has shaped a world of silenced and intensified objects: a pale, quiet, sparsely furnished place in which things are at once more and less than themselves.

It's crucial to note that this parallel world is not an imaginary place to escape to. It sits quietly inside the functioning world, and casts a new light on its contents. A collection of things to look at, Swallow's sculpture also gives us a way to look at things – a slowed-down, mesmerised, almost reverent regard for the life that objects lead in time. 'I still think the time invested in a piece is somehow contained or embalmed in the object in the final result and also contributes to the time an audience can spend with a piece', Swallow says. 'There must be an equation there ... Again I'm thinking of the phrase "to give something time"'.[1] An account that does the works justice will need to take them one by one – in their own time, so to speak – and also keep an eye on how each new object seems to enlarge the meanings and uses of the others.

YESTERDAY'S ROBOT

Swallow's talent for giving time has been plain since his first solo exhibition in a dealer gallery space, at Darren Knight Gallery in Sydney, in 1998. Part of the pleasure of *Repo Man* was that the things he chose to give time to were so common and disregarded. This was not long after the brief ascendancy of the stylistic tendency dubbed 'grunge', and it was easy, on hearing of a young artist who made models of old hi-fi gear from cardboard, to imagine some strategically shabby objects patched together from, say, duct tape and pizza boxes. But the work in *Repo Man* was something else. Hunkered on low grey plinths were some of the quietest sound-systems ever built. Working with a Stanley knife, compass cutter, steel ruler, and sheet after sheet of grey binder's-board, Swallow had fashioned 1:1 models of the video games and tape decks that time forgot: the X-Bass Woofer, the Stereo 'Twin', the Turnin' Turbo Dashboard. Entering the show felt like stepping into a hi-fi shop whose contents had somehow been three-dimensionally Xeroxed.

Timing is everything in Swallow's art. The *Repo Man* sculptures demonstrated his knack for pausing objects at the very moment they emit their last pulse of currency.

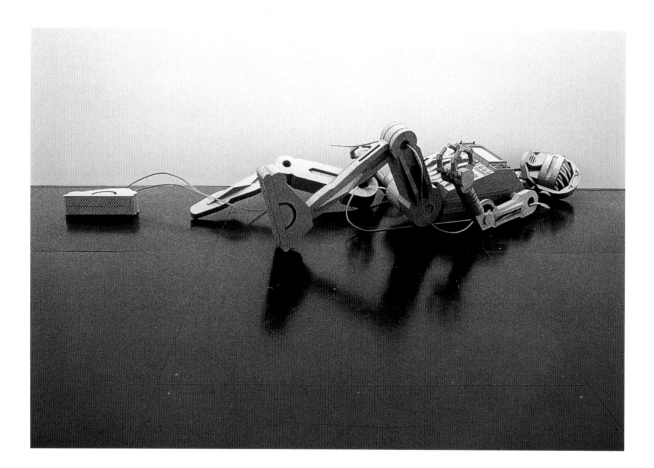

Humans are Smarter 1998
binders board, glue
220 x 101 x 37 cm
The John McBride Collection

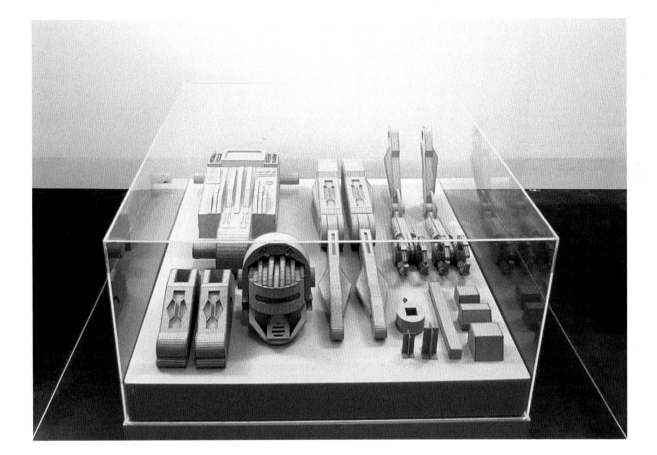

Humans are Smarter / Prequel 1999
binders board, glue, wooden shelf, plastic case
56.2 x 100 x 100 cm
The John McBride Collection

For an audience today, music boxes from the nineteenth century seem merely, generically, old. It's the sound equipment that dates from our own early days that seems shockingly archaic. Long since overtaken by Walkmen, CD players and iPods, Swallow's tape decks were, by 1998, the mules of the audio world – lowly, dust-coated, paint-bespattered. But for kids born in the suburbs of Australia in the 1970s, these tape decks and boom boxes had been dream possessions, objects stared at and longed for in their every detail; inside their sleek exteriors, songs were recorded, stored, ritually replayed. And here was an artist, like some hobby shop Proust, bent on recounting their every detail. Perhaps the most moving outcome of Swallow's commitment to specifics is the way it remembers and honours forgotten sounds and sensations: the faint stretching of sound when you pushed play and the sprocket-wheel took up the slack; the play button clicking heavily up when the tape reached its end; the way a tangled cassette came out on a shiny brown leash, like an astronaut attached by his life-line to the vast angled face of the mothership...

But before these sculptures are memorials or metaphors or anything else, they are things that Swallow *makes*, and their mystery and poetry rise from the manner of that making. In keeping with his art school transition from print-making and painting to sculpture (Swallow studied in the drawing department of the Victorian College of the Arts in Melbourne), the *Repo Man* works are, effectively, drawings turned into sculptures. Working on the flatland of his studio table, Swallow sliced and incised sheets of cardboard, peeling the fibre away in thin slivers to create shallow detailing. These sheets were then folded up and glued shut, with (as Swallow likes to remark) a sample of studio air sealed inside forever. The results have the satisfying accuracy – and tense calm – of an expert hobbyist's cardboard kingdoms. This is a sculptural world through which viewers move carefully, for fear of jostling the artist's precision arrangements.

The nearer you get to these triumphs of detail, however, the farther away they seem to be. The cardboard drains away the expected sheen and veils the objects in a granular softness; they look covered in dust, or even impacted from it. Details vary, but the works are united by one thing: the vacant recesses where the tapes should go. Silence is the price these empties have paid for their odd new lease on life: 'I wanted to take them out of time and silence every noise they made – immortalise them like a building

that's too old or important to allow people to enter its architecture', Swallow says. The results look like monuments to their own obsolescence, and, perhaps, to ours – market stall meets Mayan tomb.

Nothing dramatises the future's use-by date as vividly as yesterday's robots. At the centre of *Repo Man* lay a robot that Swallow had crafted with squint-eyed care from the same batch of grey cardboard. A composite of dozens of movie-fed memories – C3PO is in there, so are Robbie the Robot and RoboCop – *Humans are Smarter* is a comic testimony to how the styles of the present influence our dreams of the future. Boasting feet as clumpy as toasters, a mouth like an ancient intercom, and dawn-of-disco headphones, he dates from a bygone moment in science fiction, when robots wore their private parts on the outside (much as stereos, at the same time, were shouldered like hay-bales rather than slipped into pockets or back-packs). Now destined for the heap of technological also-rans that contains Beta videos, the robot looks less like he's been nobly slain in battle than unplugged and raided for bits by a salvage artist. From *Pygmalion* to *Frankenstein* to *Star Trek*'s Data, Western culture's hard-wired sculptural myths and cautionary tales of artistic creation concern the making of surrogates that take on their own unruly life. Swallow's spin on these tales is to fabricate a companion that's already defunct, taking the robot out of action even as he brings it into being. The artist presides, with humour and a cruel kind of compassion, over the reconstruction of a broken object from the toy-box of his own past: *some reassembly may be required.*

Here is the paradox on which Swallow's art turns. There's this wish to repossess an object by hand, to regain a lost form. Yet memory refuses to be pieced together as if it were a model aeroplane kit. The secret knowledge of the repo man (the exhibition was named after Alex Cox's 1984 film) is that every repossession is also a dispossession, and that even the most attentive sculpture silences what it reclaims. This sounds solemn, but the works have always been alert to the lighter side of our attempts to grant things weight. There was something beautifully futile in Swallow's choice to pay tribute to outdated recording machines by building another, even humbler set of containers for memory: an exhibition of cardboard boxes. And the overwhelming effect of *Repo Man* was not one of diminishing satire or melancholy, but rather a surprising tenderness. These sculptures of worn-out and mass-produced things seem

as attentive and interested as portraits, and almost preternaturally alert to the ways in which objects speak – or tellingly refuse to speak – for us.

PLAY PAUSE STOP RESUME

The problem with a lot of big art is that it's only big on the wall. Swallow wants to make another kind of object – a small thing that grows large in memory. Few sculptures achieve that goal as ingeniously as the slowly revolving ready-made turntables he has been colonising with hand-made model worlds since the mid 1990s, and which he first exhibited in force in the 1999 Melbourne International Biennial under the title *Even the Odd Orbit*.

On a long, low shelf in front of a panoramic eighth-storey window in Melbourne's Telstra Building, Swallow arrayed twenty-one trays of time. It was as if a travelling salesman had arrived, popped the locks on his cases, and lifted the lids on world after small world. Each turntable supports a scene at once intensely detailed and weirdly pushed away; there's a wrong-end-of-the-telescope feeling. Out there through the long band of windows, the sounds of traffic muffled at this height, the buildings of the city were densely stacked. Inside, the players and their miniature architecture slowly turned, like a dream the city didn't know it was having.

Swallow's turntable sculptures are wonderfully efficient devices for turning passive browsers into active peerers. The sheer intensity of their detail – one imagines the artist-hobbyist immersed in his Airfix utopia, concentration heightened by glue fumes – induces a corresponding focus in viewers.

Slowly but surely, each work in *Even the Odd Orbit* wound you into a realm – the turntable precinct, perhaps – of scale-shifts and subtle displacements. Meanwhile, seen in the shadow of the models, the city out the window began to look secretive and oddly unsure of itself. Melbourne became a miniature, an unreal estate. Rising above the player in *Model for Chimpanzees with Guns* (1999), for instance, is a model of the Telstra building itself, its roof the stage for a stand-off between humans and a turning monkey. So even as you stood, god-like, over this model, it seemed to rise unseen into the space above and behind you. Swallow's first major public exposure, the Biennial established in the minds of gallery-goers a sense of the way things go in his

Model for Chimpanzees with Guns, detail from *Even the Odd Orbit* 1999 turntable, binders board, altered plastic figurines, paint

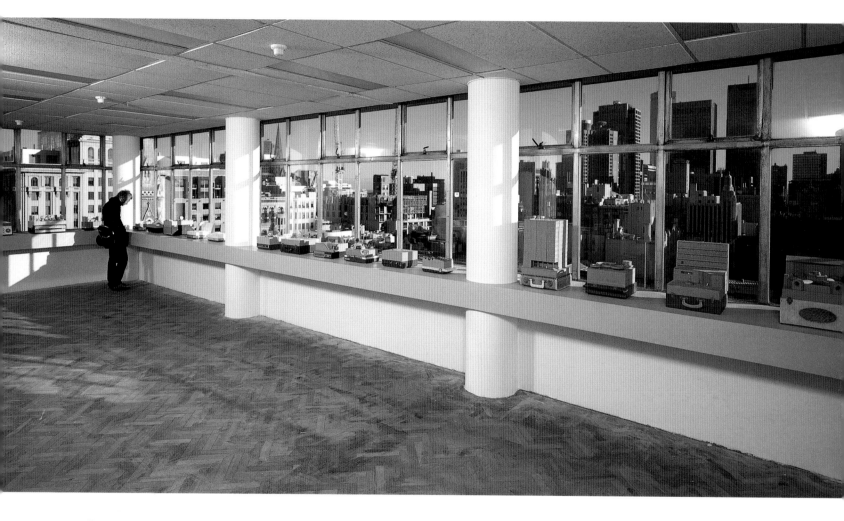

Even the Odd Orbit 1999
Melbourne International Biennial, 1999

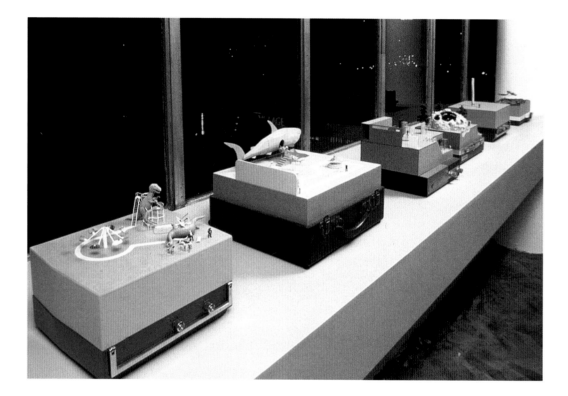

Even the Odd Orbit 1999
turntable, plastic binders board, altered plastic figurines, paint
Melbourne International Biennial, 1999

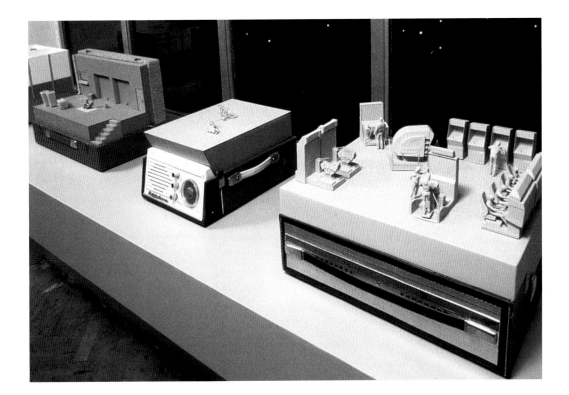

Even the Odd Orbit 1999
turntable, plastic binders board, altered plastic figurines, paint
Melbourne International Biennial, 1999

art: the future circling the past, small things opening on to deep time, scale going strange and unstable.

All Swallow's sculptures enfold a commentary on earlier art, but the turntables are especially *studious* works. Amplifying the childhood habit of seeing domestic surfaces as potential staging grounds – every table-top a city, every cupboard a hideout – they show a young artist collecting song titles, film scenes, dreams, places and art histories, and fitting them together on the flat earth of each turntable. Among the precedents mixed and miniaturised on their surfaces are Duchamp's 1941 *The Box in a Valise* (art's most famous portable world), Joseph Cornell's boxed heavens, the funereal white-worlds of George Segal, the figurative ensembles of Juan Muñoz, and resonances accumulated from a reading list that included JG Ballard and Robert Smithson on the prehistoric future, Susan Stewart on the aesthetics of the miniature, and Gaston Bachelard on the poetics of space.

The turntables survive group exhibitions so well because they are exhibitions unto themselves: plug-in wonder cabinets, museums in boxes, portable collections. Many of the early turntables actually depict collections: a children's museum, a Ricky Swallow exhibition. And with their chubby knobs and bakelite handles, the 1950s and '60s portable players (the Walkman's dinosaur ancestor) are themselves a collection, one gathered from country thrifts and Melbourne's Camberwell Market. Swallow's first experiments with them date from a moment – the mid-1990s – when artists had begun to reclaim as working models the very devices that museums were stowing in their basements as methodologically suspect: flyspecked dioramas, low-tech gadgets, wayward and eccentric collections.

Swallow's turntable models make trouble in the paradise of the diorama by the simplest of means. They plug it in and make it move. 'I wanted to tamper with this stillness', he says. 'To bring a model into real or actual time, to slowly wind its inhabitants into expression.' Sculptures with moving parts often risk corniness or look-at-me cleverness, but Swallow's use of found objects to propel the models makes the movement seem fortuitous and mysterious – something given – rather than coy or contrived. The movement ushers in a further mystery. Museum dioramas tend to look back, and architectural models to look forward; but it is not clear which way the turntable sculptures face. Are they descriptions of how things were or predictions of

Against the Ape Rule 1999
plastic, turntable, milliput, spray paint
25 x 42 x 36 cm
Collection of Samuel and
Shanit Schwartz, Los Angeles

Plastruct 2000
Installation view
Karyn Lovegrove Gallery, Los Angeles

how they shall be? And is the one moving part in each pale world a sign of life about to restart or of things winding down? No answer is forthcoming, and the repetition – part pleasurable, part melancholy – strands the figures in a loop of time. The bicycle rider falls, and falls, and falls. The street-cleaning machine sweeps, and sweeps, and sweeps. The story turns, and turns, and meets itself. And the faint scrape of the hidden player mechanism is more involving than any one soundtrack could be. It creates a charged, expectant silence into which we're free to project soundtracks of our own. There's even a sense in which these works *are* soundscapes – physical emanations of the music hidden beneath, songs risen into sculpture.

A standard line on the newer turntable models (seen in the 2000 exhibition *Plastruct* and the 2001 exhibition *Swallow/Swenson*) is that they illustrate scenes from films. Certainly, it's good, train-spotting fun to pick the titles and genres in play: sci-fi sublime (*2001: A Space Odyssey*), cybernetic Western (*Westworld*), future shock (*Planet of the Apes*). But Swallow is up to something more intricate here than straight quotation. Cinematic settings and actual places meet and merge in these turning worlds. A human stalks apes near the Fitzroy public toilets in Melbourne (*Against the Ape Rule*, 1999); robots find themselves trapped in the kind of plastic road barriers that can be

seen on Melbourne streets (*Wronging the Robots,* 2001). What Swallow proposes here is not just a way of looking at movies, but a way of looking at the world through them. For a generation that grew up not with Sunday matinees but rather the pause and rewind button, a single scene, played and replayed, can accumulate a power and persistence that exceeds the surrounding movie, spins it away from its surrounding narrative, and casts a spell over real things and places. In this light the turntables read as life-support systems built by an especially ardent and attentive fan: devices to keep the spell going. Moving stills, we might call them.

There is, however, nothing passive about the acts of reverie that the turntable models inspire. Yes, the works reel you into their worlds of detail, but from within those worlds we get to look back toward the everyday at a steep and strange new angle. Each piece insists in some way that the fiction it supports is nested within a larger fiction, which is the turning world we inhabit. In the later groups, which exchange the op-shop chic of mid-century players for the blank sleekness of contemporary hi-fi, Swallow arranges increasingly playful transitions between the architecture of the turntables and the architecture of the world they support. Buttons rise into stairs or pipes, rubber stoppers extend into barnacled pillars, and details from beneath are reproduced above. All of this leads us to wonder where the 'sculpture' stops and its 'support' begins (inversions of plinth and sculpture are a Swallow hallmark), and where we stand in relation to it. In one of the most poetic turntables (aptly built on a 'Pioneer' player), *Model for the Taming of the Moon* (1999), three hobby astronomers aim their telescopes at models of the moon, as if unaware of the real thing, or scared of what it might tell them. Their obliviousness to us as they go about their task seems touching and a little absurd, but only as absurd as the ritual of art-watching might seem to someone watching *us*.

The scope of the works again expands when you start looking for connections between the turntables and Swallow's other sculptures. Follow the white bike through his work (from the tiny *Model for Broken Bones* to the life-size *Peugeot Taipan, Commemorative Model (Discontinued Line)* and then back to *Model for Evil Indoors (Teenage Séance)* (all 1999) and you'll find yourself pulled through a series of scale-shifts, like Alice in pursuit of the White Rabbit. (The same game can be played with the telescope, the shoes, the sleeping bag.) In this world of delay and deferral, every object seems

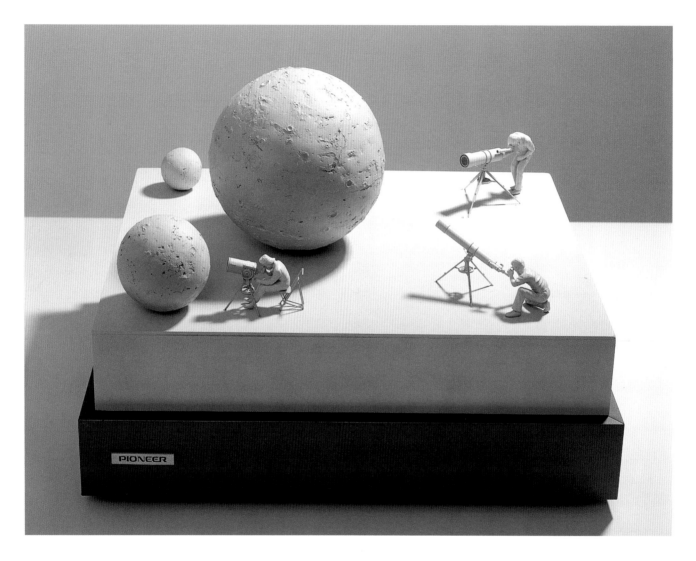

Model for the Taming of the Moon 1999
polystyrene, plastic, turntable, milliput, spray paint
30 x 43 x 34 cm

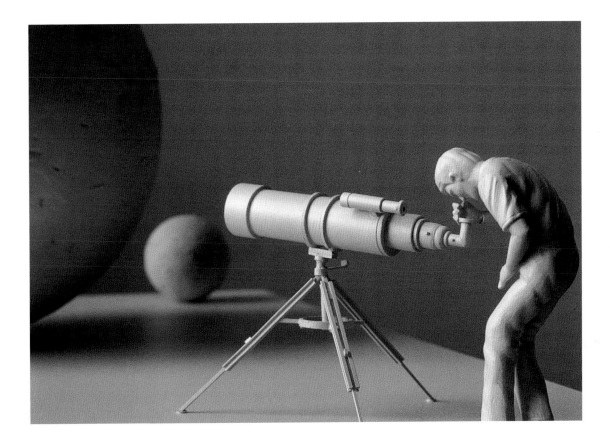

Model for the Taming of the Moon, detail 1999
polystyrene, plastic, turntable, milliput, spray paint

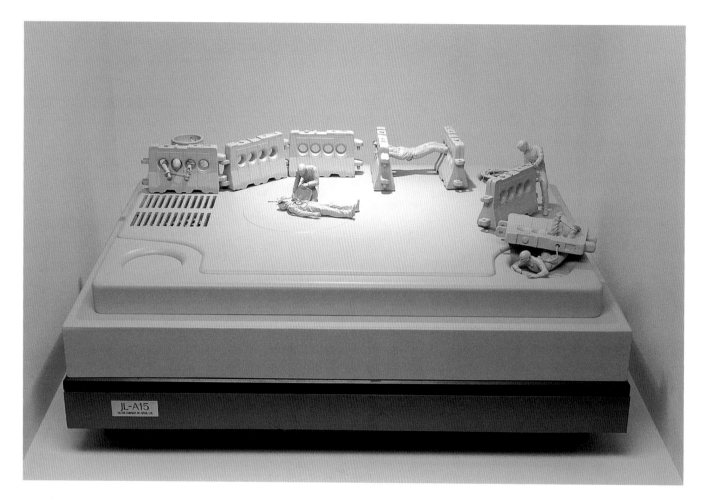

Wronging the Robots 2001
turntable, plastic epoxy, spray paint
23 x 46 x 35 cm
Collection of Warren Tease
and Katherine Green, Sydney

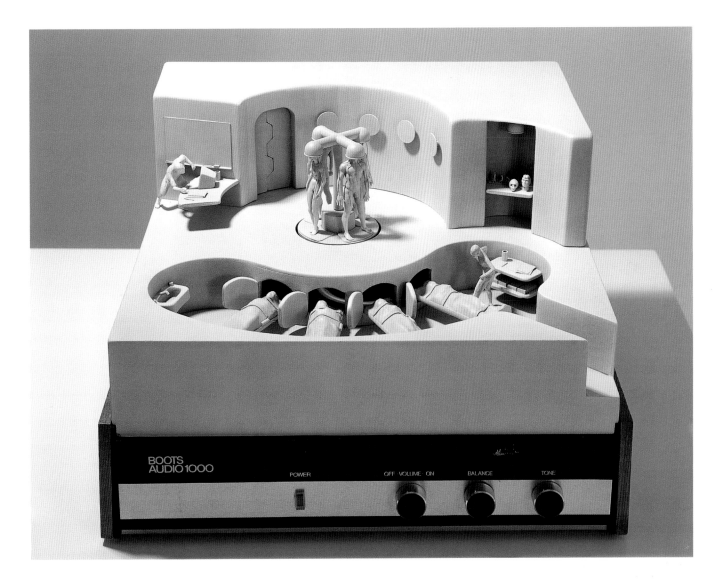

Building Better Beings 2000
turntable, plastic epoxy, PVC
24.6 x 38.7 x 37.5 cm

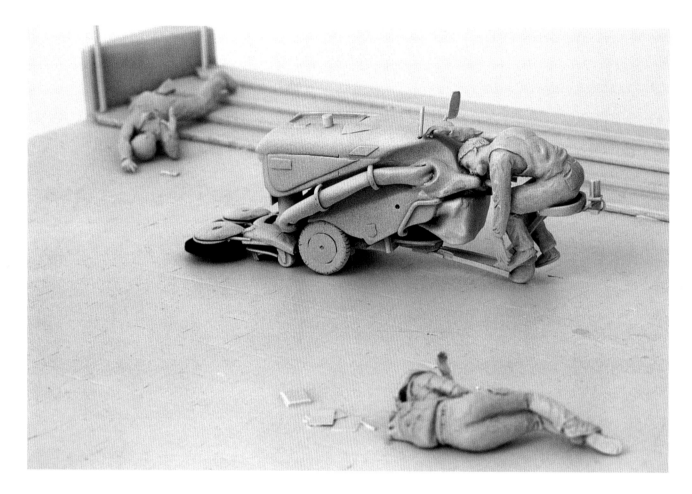

The City Sleeps, detail 2000
turntable, resin, epoxy, PVC

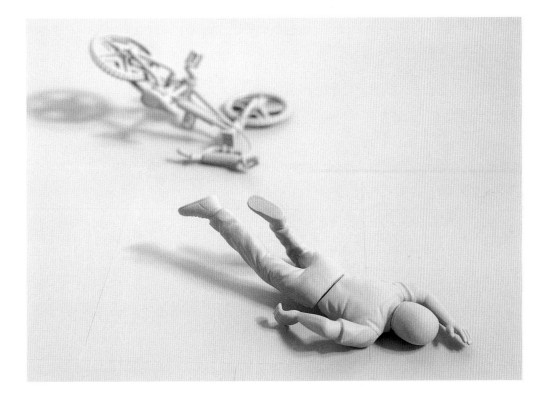

Model for Broken Bones, detail 1999
turntable, plastic, spray paint
Kleimeyer and Stuart Collection, Melbourne

to recall or predict another, and the result is to unsettle your own sense of time and scale. The first turntable that viewers saw in *Even the Odd Orbit*, for instance, was a model of a Ricky Swallow survey exhibition. Among the matchbox-sized exhibits in this work from 1999 was a version of the 1998 work called *Humans are Smarter*; in this miniature version, the robot has been dismantled and displayed like a suit of armour in a museum case. It thus predates the *actual* dismantled sculpture, not seen publicly until later in 1999, which has the subtitle 'prequel'. When the latter work turned up in a real Ricky Swallow exhibition at Sydney's Museum of Contemporary Art in 2001, it thereby fulfilled the miniature's prediction. As the word 'prequel' suggests, these scale-shifts and time-warps closely parallel the way a film-maker builds time and space around a single object or character with flashbacks, foreflashes, looped chronologies and sudden shifts between long-shot and close-up. Not many careers can boast this willingness to commandeer art history's trustiest tool – chronology – and put it to creative misuse.

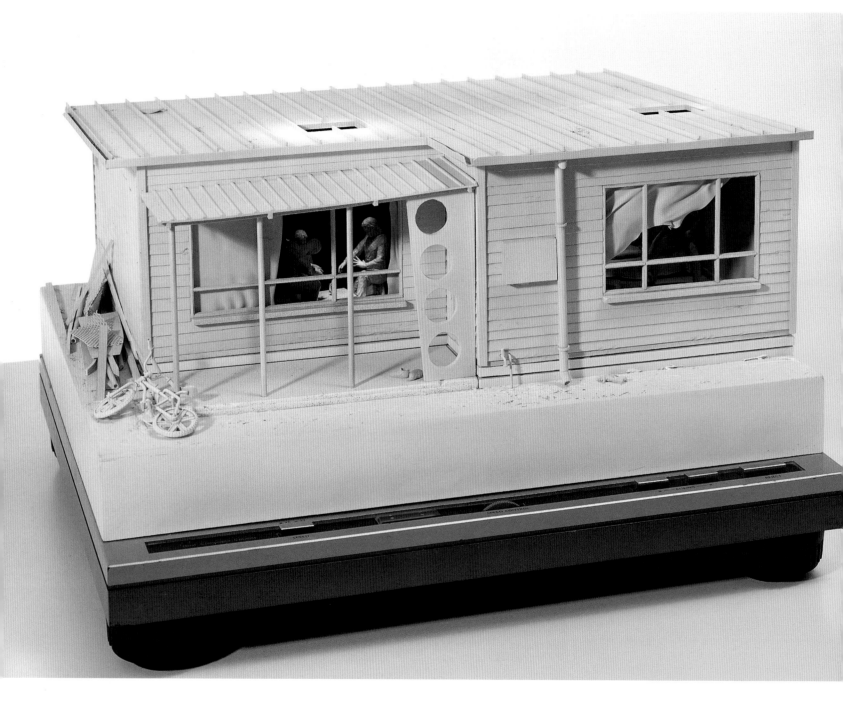

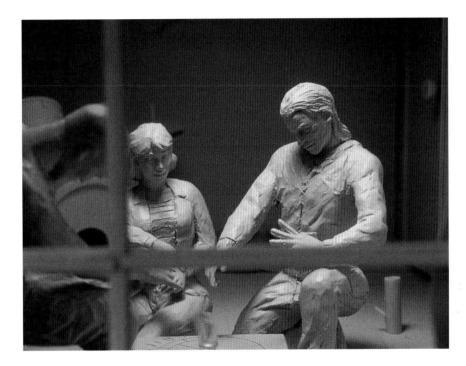

Model for Evil Indoors (Teenage Séance), detail 1999
turntable, plastic, milliput, spray paint

Facing page:
Model for Evil Indoors (Teenage Séance) 1999
turntable, plastic, milliput, spray paint
43 x 36 x 20 cm
Collection of Matt Aberle, Los Angeles

However grim the verdicts that the archaeologists of the future will draw about the late twentieth century, it's a sure bet that they won't be able to complain about the quantity of evidence. Picture them, somewhere up there in the twenty-fifth century, beginning to work their way down towards our time. Down they dig, past the silicon houses of 2324, remnants of the air-trike craze from the summer of 2250, the collapsible dogs of 2102 and titanium Frisbees of 2036, until at last they reach the late twentieth century, and a buried army of objects rises from the lowering tide of earth – bygone sneakers, Jurassic iMacs, a mountain range of relics and fragments from the Age of Unnecessary Stuff.

A subtler version of this time-travelling fantasy propels Swallow's works of 1999 and 2000. They are rich with a sense that the functional objects all around us are riddles for the future to solve. His ambition, you might say, is to find a way to bring that strangeness home to us now, to view the present as if it were past. Looking at the works from this period, you get the sense that 'sculpture' for Swallow is not a category of objects so much as a process or time-zone through which existing objects are passed before being returned to the world: frozen, stratified, fossilised, even barnacled. In *Game Boy (Concept Model)* (2000) Swallow subjects one of the twenty-first century's foremost time-wasting devices to the wastes of time. The screen is dead, the game won't go; barnacles encrust the buttons. But there it is, proudly displayed, as if in some antiques road show of the future. The title further warps the time-frame by calling the object a 'concept model'. There is, after all, a vast category of brand-new consumer objects that have been hurried into age: the stone-washed, the sepia-toned, the patinated. A pre-aged Game Boy is no more ridiculous than a rusticated table or some pre-faded jeans.

In *Repo Man*, from 1998, Swallow had given a fragile permanence to objects about to fade from memory. In *Future Tense*, from 1999, he triggered a comedy of culture by smuggling age into objects from the present. The effect has extra bite when Swallow ages an object that is itself designed to stop or at least brake the effects of time – like an art museum. With their vaults, alarms, fire-walls and temperature controls, museums are life-support systems for ageing artefacts. In his 1999 sculpture *Model*

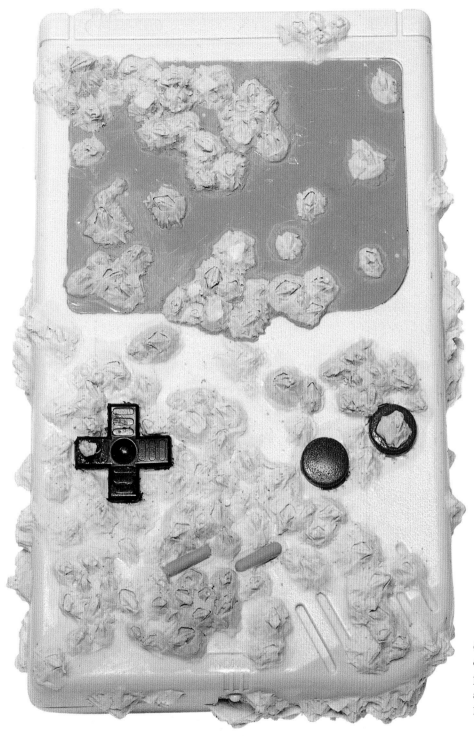

Game Boy (Concept Model) 2000
edition of 5
pigmented resin
scale 1:1
Laverty Collection, Sydney

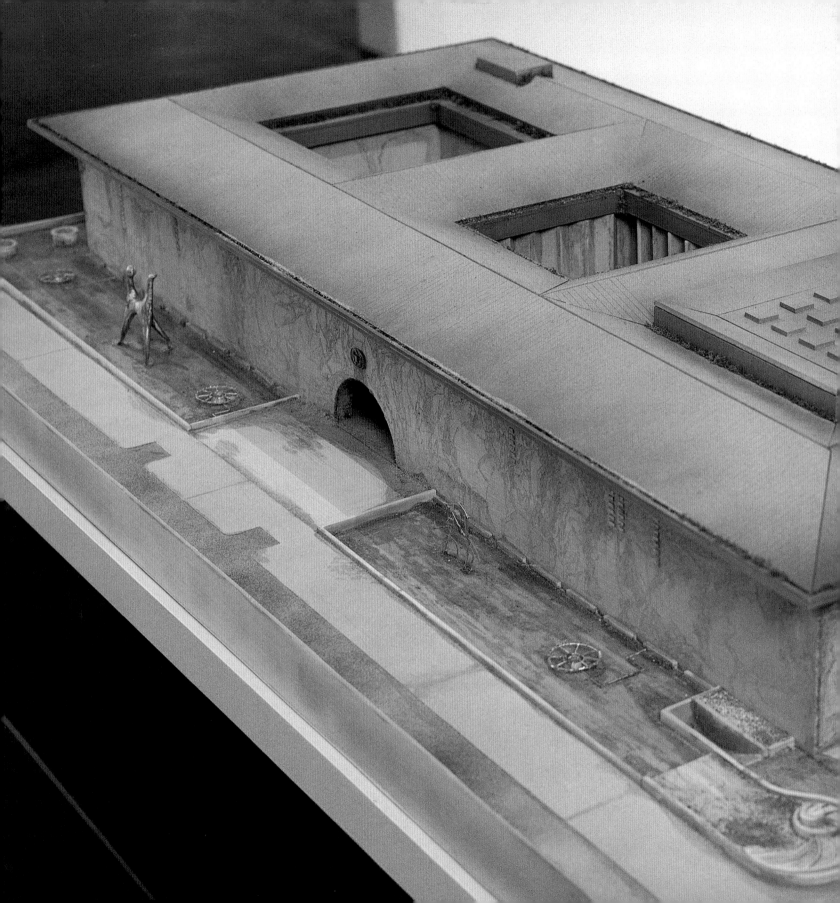

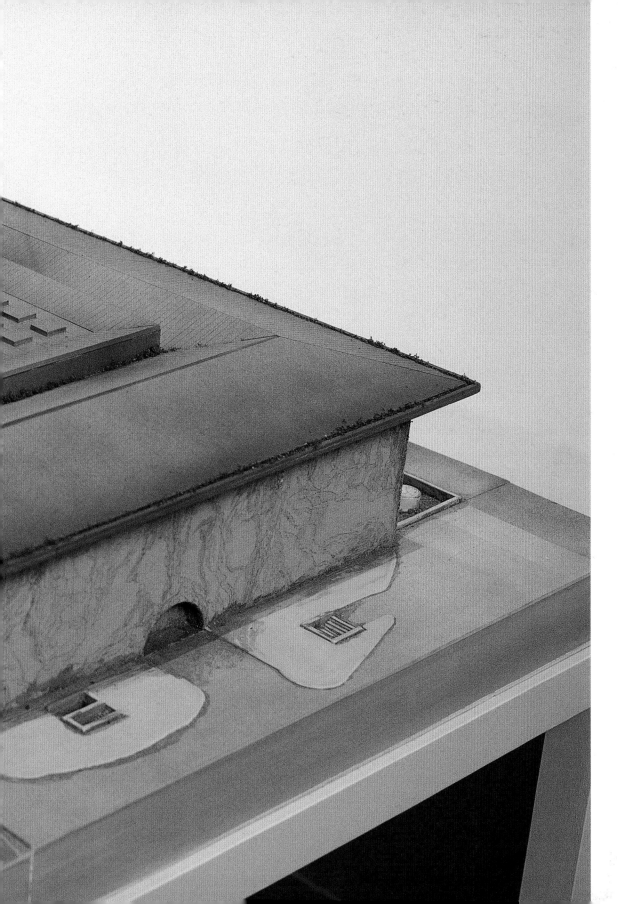

Model Sanctuary (Overgrown) 1999
plastic, styrene, milliputt,
plaster, modelling materials
110 x 65 x 20 cm
Collection of James and Jacqui Erskine,
Sydney

Sanctuary (Overgrown) Swallow sends one of the biggest in Australia – the National Gallery of Victoria – into an uncertain future. At the time, the Roy Grounds-designed building was closed in preparation for a makeover, and its foyer had recently hosted an architectural model that proposed, as such models tend to, a future free of vagrants and rubbish. *Sanctuary* is the model's grim twin, a bad dream of the gallery's future. Swallow remakes the building as a slime-streaked culture bunker, its moat dry, its sculptures rusting. The National Gallery was a hard-to-miss target, and Swallow had been lining it up for a while. He walked past it every day on his way to art school in Melbourne. Like Ed Ruscha's *The Los Angeles County Museum on Fire* (1965–68), a masterpiece of irritation that hovers influentially behind *Sanctuary*, the sculpture is an act of creative, half-smiling exasperation with an institution that bulked oppressively large to an emerging artist. The title puns on the daunting size of Grounds's building: *overgrown*. With the revamped National Gallery of Victoria now opened and inner-city Melbourne creaking beneath new cultural real estate, Swallow's prediction doesn't look like coming true any time soon. (Still, it is in the nature of undated predictions to sit just ahead of us and wait for the circumstances that will prove them right.)

Model Sanctuary (Overgrown) was the first of five sculptures that viewers saw in *Future Tense*, the exhibition that won Swallow the 1999 Contempora Award. Seen in its wake, the other sculptures pressed on the imagination as hypothetical exhibits from the time-warped museum. Here was a vision of 1999 from the future's point of view, but extrapolated from wonderfully inadequate evidence. Like the early archaeologists who discovered dinosaur bones and deduced that men had once been giants, the curators of Swallow's museum seemed to have pieced together the twentieth century's gods and monuments from the remnants of a sixteen-year-old boy's bedroom. In *Model for a Sunken Monument*, Darth Vader, the heavy-breathing bad guy of the *Star Wars* films, has been recast as a slumping statue. (This is not, it turns out, such an unlikely proposition: Vader figurines play the part of the lord of the dead in Haitian voodoo altars.) And in *Evolution (In Order of Appearance)*, a line-up of five tiny bone-white resin skulls, one of the consoling stories the human race sometimes tells itself has been quietly and decisively monkeyed with. What appears at first to be a text-book evolutionary sequence – from jut-jawed Cro-Magnon to high-browed modern human – turns out to have been infiltrated by a Hollywood android. 'I guess I was trying to be

Facing page:
Model for a Sunken Monument 1999
MDF, acrylic
110 x 220 x 150 cm
Collection of the National Gallery of Victoria, Melbourne. Purchased through the Art Foundation of Victoria with the assistance of the Joan Clemenger Endowment, Governor, 1999

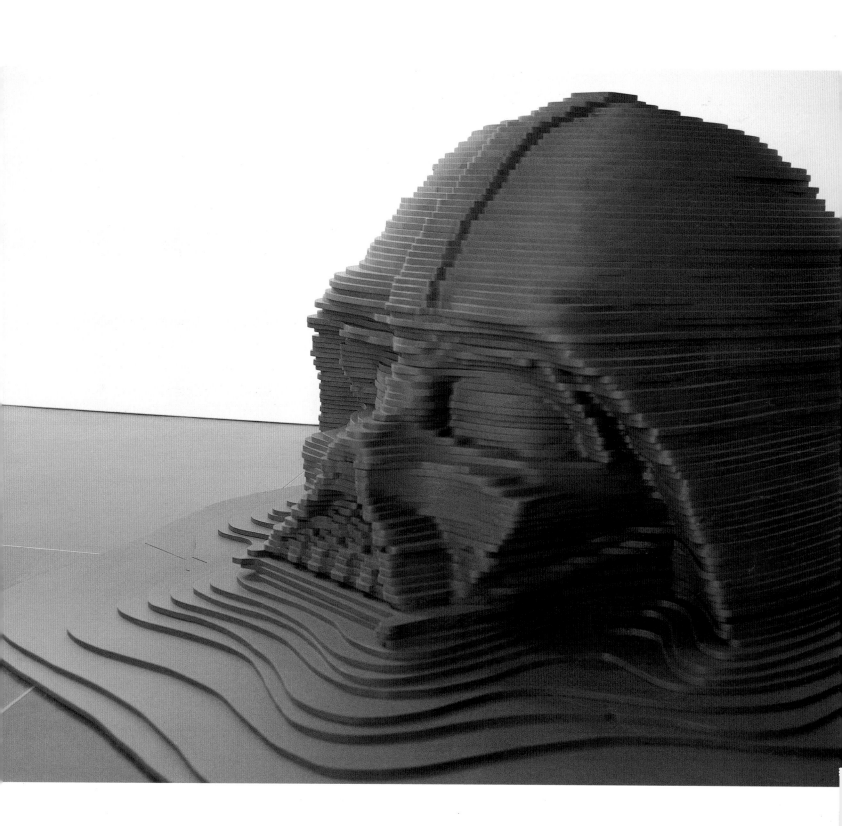

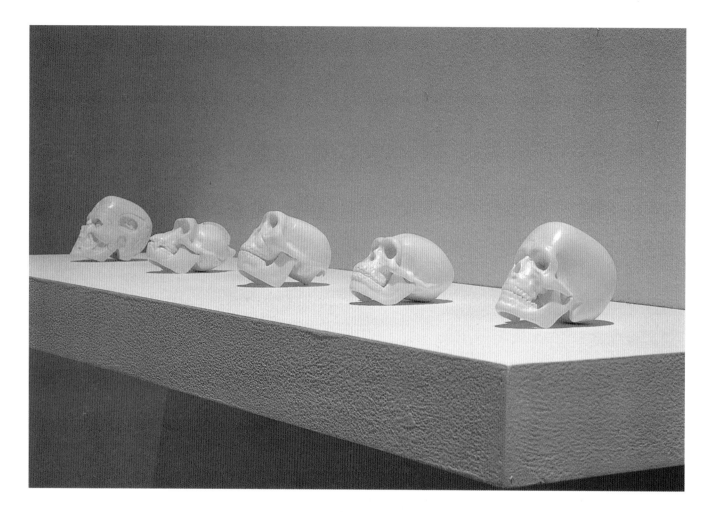

Evolution (In Order of Appearance) 1999
cast resin
5 units, each approx. 5 x 2.5 x 5 cm
Laverty Collection, Sydney

the kid who moves the other kids' blocks around, changes the order when no one is looking', says Swallow. 'So the Terminator skull is thrown in there to tamper with a clean line of history – time made malleable.'

By 2000, the year of his *Unplugged* exhibition in Sydney and *Above Ground Sculpture* in Dunedin, resin had replaced cardboard as Swallow's material of choice. Pouring layer after layer of pigmented resin into the mould and then hatching that form out as a solid, Swallow was layering his sculptures in the studio like miniature geologies. He was also mimicking the industrial processes that produce plastic toys and consumables by the thousands. (Swallow was the kind of kid who was at least as interested in the casting seams on his toys as he was in their imaginary lives.) *We the Sedimentary Ones/Use Your Illusions, Vol. 1–60* (2000) is a grid of drop-jawed skull key-rings that have been grown layer by chemically coloured layer. The result collides the drama of the big budget archaeological dig (the discoverer unearthing ancient skulls and displaying them in solemn rows) with the comedy of the beachfront treasure hunt (the hobbyist dreaming of El Dorado and discovering nothing but rusty key-rings).

What Swallow stirs in these objects is a feeling that sculpture is a kind of sediment, and that all things – our bodies included – sink and rise through layered time. It was an odd, almost stubborn endeavour, to be making such emphatically physical works in a supposedly virtual age. And it was by colliding the virtual and the archaeological that Swallow created what was, until recently, one of his best-known works. In *Apple 2000* (2000), Swallow swells the now phased-out Apple computer company logo to three dimensions by recasting its rainbow test pattern as resin strata. And this expansion brings into view the biblical story of the forbidden fruit and the fall from innocence into knowledge. Swallow has toppled the apple from the weightless, textureless domain of the computer screen into the mortal world of touch and weight (and taste: Swallow bit the apple from which this object was cast). The flickering quick time of cyberspace has been invaded by the vast time of archaeology, and a piece of pixelated nothing has become a stratified relic – a literal fossil fruit.

The *iMan Prototypes* (2001) arrange an even more hallucinatory merger of traditional form and 'cutting-edge' design. Imagine a computer centre as catacomb. In Swallow's only venture into computer-aided design and industrial processes, he subjected the human skull to an upgrade on design principles pirated from Macintosh's

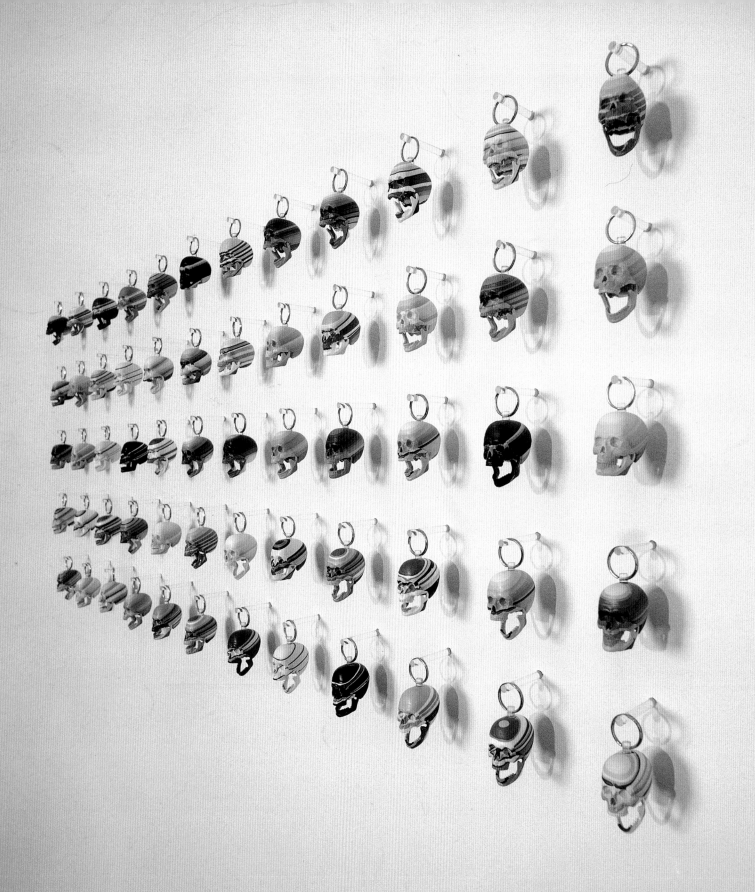

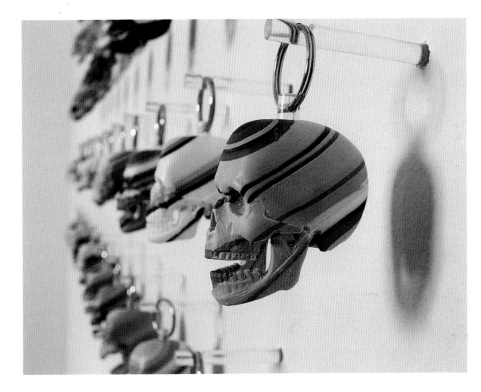

We the Sedimentary Ones / Use Your Illusions Vol. 1-60, detail 2000
pigmented resin key rings, acrylic rods

Facing page:
We the Sedimentary Ones / Use Your Illusions Vol. 1-60) 2000
pigmented resin key rings, acrylic rods
each approx. 5 x 3.5 x 3.5 cm
overall 57 x 123 x 3.5 cm
Private collection, Wellington, New Zealand

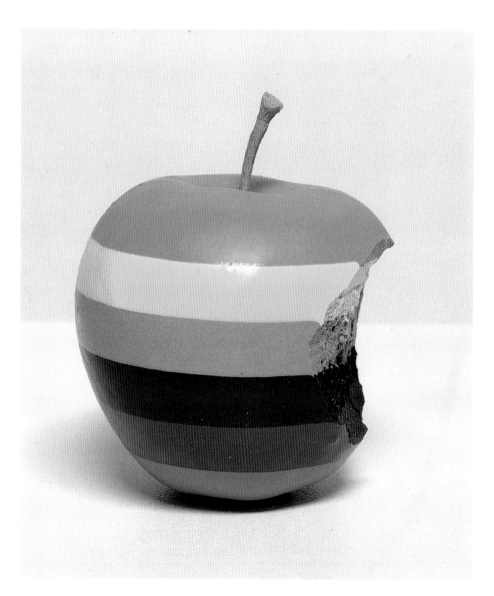

Apple 2000 2000
edition of 12
pigmented resin
9.5 x 7.5 x 7.5 cm

iMac computers, whose see-through candy-coloured shells, in his words, 'sort of embarrassed the beige history of computers'. The skulls were injection-moulded in a choice of (collect them all!) four colours. That, after all, is what corporate design purports to offer: the chance to stand out, to be an 'I' man, by exercising consumer choice. Human skulls are often described as the final frontier in evolutionary architecture. Contemporary design, however, abhors the prospect of human self-sufficiency, and styles each new product as an indispensable extension of your body and mind.

The *iMen* mock this logic by taking it to absurd, even terminal extremes, and creating designer accessories that are dead on arrival. Swallow thought of each of his brain-boxes as 'a desktop accessory to accompany the iMac in the same way that a skull might sit mortally beside a book or a candle in a still-life painting'.[2] Is it abstinence or consumption that these strange idols preach? The only valid answer to that question is 'both'. The *iMen* recast high-end commodities in the shape of the *vanitas*, with its omens of the emptiness and futility of earthly posessions. At the same time their very elegance and force as artworks testifies to Swallow's attraction to and fluency in the languages of contemporary design, and thus to the force of his ambivalence. Complete with spinal holes for power cables, vented 'ears', and a death's-head logo, these parodies of contemporary objects of desire are themselves extremely desirable.

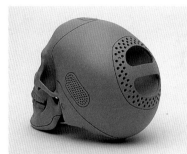

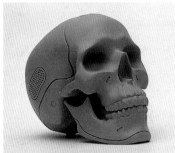

iMan Prototype 2001
cast resin
Collection of the artist

It's vital to look at these objects alongside Swallow's watercolours, with their cast of gadget-crazy apes. (He calls them 'drawings', but they are quite unlike the technical drawings one might expect of so exacting a sculptor.) Dressed in sneakers and shell-suits, the apes clutch their cellphones, lap-tops and Game Boys with a zeal that suggests those objects might prolong the owners' currency, give them a jump on the future. Other drawings are Luddite in spirit: a Sony boom box spewing smoke, an ape smashing a computer. Swallow's account of these fated objects is all the wittier for being rendered in watercolour, a centuries-old technology that, in his hands, shows no sign of obsolescence. But the paintings are something both less and more than illustrated moral tales, because it's unclear throughout exactly where the line between ape and human lies.

Swallow is a deft enough watercolourist to imply, in those drawings where he depicts himself, that there's a bit of ape in him and some of him in them. *Planet of the Apes* is, as they say, a key text, and there's something tender, almost brotherly, in the

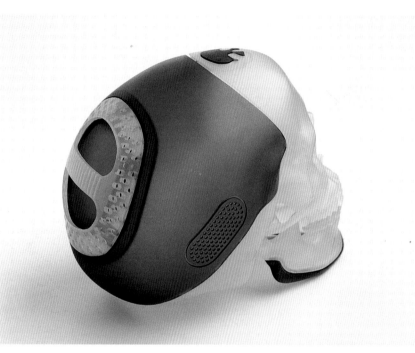

iMan Prototypes, detail 2001
injected-molded resin with colour tint

Facing page:
iMan Prototypes 2001
edition of 3
injected-molded resin with colour tint
4 units, each 16 x 11.5 x 18.5 cm
Chartwell Collection, Auckland Art Gallery
Toi O Tamaki, Auckland, New Zealand

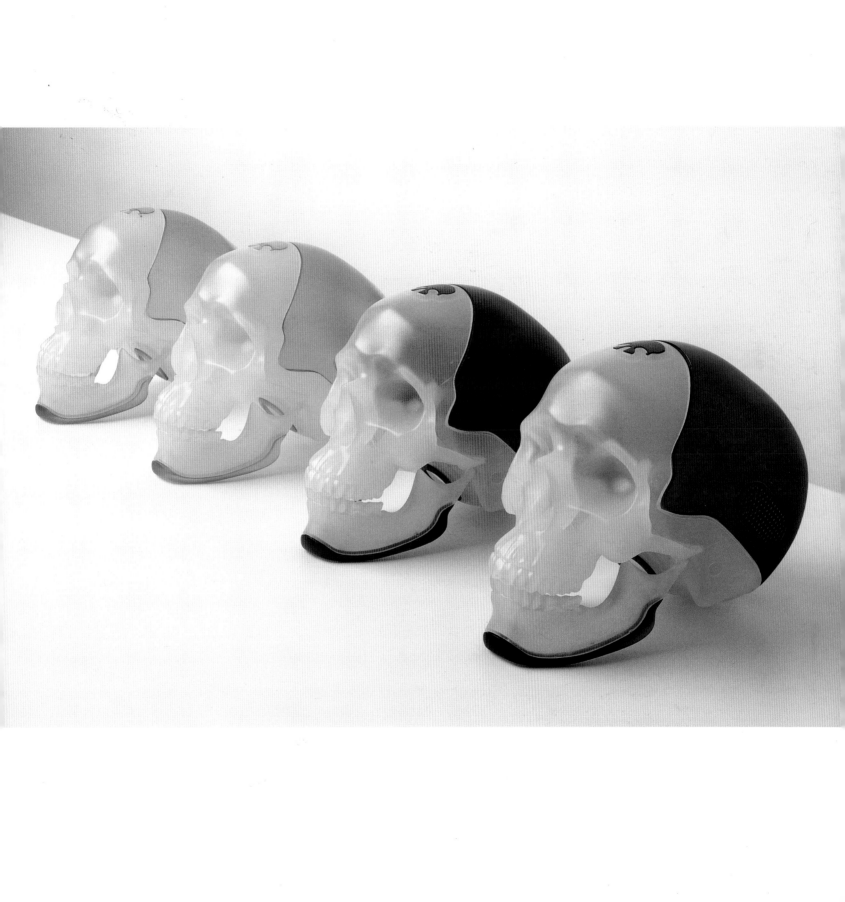

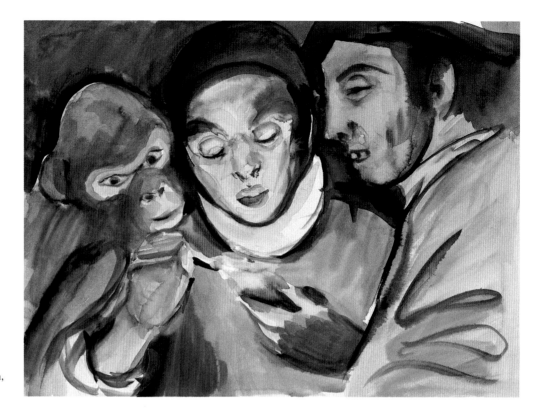

The Fable 2001
watercolour on paper
38 x 28 cm
Private collection, Wellington,
New Zealand

Facing page:
Communication 2001
watercolour on paper
38 x 28 cm
Private collection, Berkeley

way Swallow treats his hairy R&D team. Finally, the watercolours are (to use the term associated with Goya, an artist Swallow quotes in these works) caprices, serious whimsies, fluid speculations about evolution and role reversal. The apes do what Swallow's sculptural scale-shifts do: they allow us to see ourselves and the world of objects from another angle.

TRIBUTE ALBUM

It seems improbable, forty years after Pop Art, but Swallow has occasionally been chided by the crabbier of his critics for his use of what gets called 'popular culture'. Seemingly blinded or dazzled by the mere fact of reference to sneakers or tape decks or BMX bikes, with their supposed taint of 'juvenile' or 'adolescent' content, such critics miss what matters most in Swallow's treatment of popular cultural forms: the caring

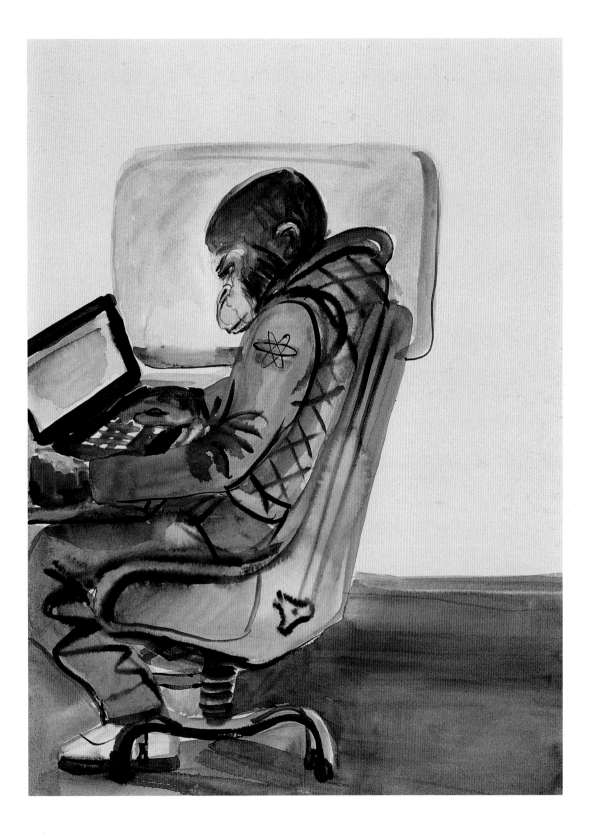

rigour of his transformations; the way the forms are remade, and in the process unmade. In fact, it's impossible to imagine Swallow resorting to a phrase as glib and sweeping as 'popular cultural forms'. For him these things are simply part of the natural landscape of objects encountered by someone growing up in the suburbs of Australia in the 1980s, and in which a still-life sculptor from the 2000s might go foraging. Here is one of the qualities that inspires special affection for Swallow's work, especially among viewers of his own age. The work insists that memories, thoughts and emotions are no less piercing and mysterious – perhaps *more* piercing and mysterious – for settling in forms that are common and shared. 'For me and people of my generation,' Swallow said in 1999, 'the stereos, the video games and the bike are almost like tributes. The work is a reference point to reactivation or revival'.[3]

Consider *Who Wants to Live Forever*, a two-part work on paper that might give special trouble to the critics just mentioned. Dated 1989–2000, it is the longest and shortest work that Swallow has ever made. In 1989 Swallow filled two pages of his sketch-book with faces from an Australian teenager's pop pantheon: members of the bands Queen and INXS, earnestly rendered in pencil. In the decade since he made the drawings, the lead singers for both bands, Freddie Mercury and Michael Hutchence, had died. And in 2000 they disappeared from the drawings too. In that year, Swallow returned to his sketch-book, erased Hutchence and Mercury in a matter of minutes, and framed the altered drawings beneath melancholically tinted Perspex. The act of subtraction has an art-historical pedigree in Robert Rauschenberg's 1953 erasure of a drawing by Willem de Kooning, but Swallow's gesture is more tender than Oedipal. After all, when Swallow rubbed the frontmen out, a bit of his own history went with them. Named after a lighter-waving power ballad by Queen, *Who Wants to Live Forever* sets grandiose visions of rock immortality beside the fact of mortal bodies. It's a touching work, literally – the act of erasure, the careful rubbing, brings that sense to the fore. (Don't mediums talk about 'drawing out' a spirit?)

Wherever one looks in Swallow's career, he seems to be feeling on the shelves of popular culture for some trace of the still-life *vanitas* – a genre that raids the present for signs of how it will look as the past. He's attempting to measure by hand – literally come to grips with – the life-span of things in the world. Fashioned with devotional care from binder's-board, paper and glue, *Vacated Campers* (2000) is a lovely memorial

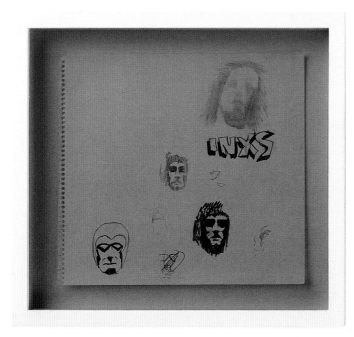 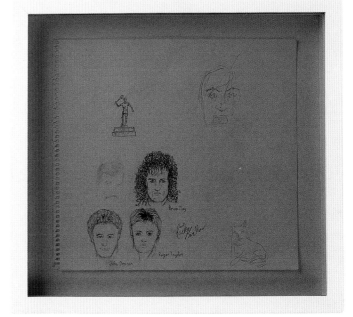

Who Wants to Live Forever 1989–2000
pencil on paper (partially erased), coloured perspex
2 framed drawings, each 33 x 36 cm
Collection of Suzie Melhop and Darren Knight, Sydney

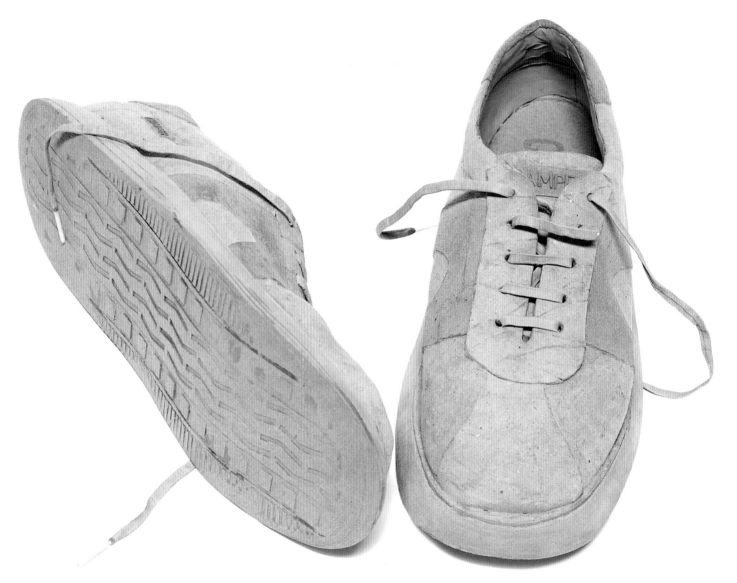

Vacated Campers 2000
binders board, paper, glue
10 x 32 x 35 cm
Collection of Suzie Melhop
and Darren Knight, Sydney

to the fleets of sneakers unevenly parked on any number of suburban back steps, the slackened uppers and worn-down soles telling their tale of use. But it also hints at some weirder and funnier disappearance – has the owner ascended, evolved, or perhaps self-combusted? The shoes (plinths for people) have an odd grey cindery softness; they might dissolve at the touch like an ash skeleton. Yet these seemingly fragile and past-it objects are destined to outlast their maker. The work thus approaches heavy themes – absence, disappearance, the endurance of objects – on the lightest of steps.

What is a devotion? A gift of time. And time is what separates Swallow's objects from the objects they resemble. From Duchamp's found and recontextualised bicycle wheel to Jeff Koons's glassed-in vacuum cleaners, there is a twentieth-century tradition in which artists have by-passed the studio and moved objects directly from world to gallery. At first glance, Swallow's recreations of shoes and appliances outwardly resemble the shopping sculpture of, say, Haim Steinbach: consumer durables (sneakers, tape decks), coldly arrayed. But for an artist coming of age in the early 1990s, when works such as Steinbach's were predictable sights in text-books and lectures, once-potent strategies of 'appropriation' no longer looked fresh. Still less fresh was the academic rhetoric in which the work had become encased, with its forced and moralising choices between 'nostalgia' and 'critique'.

Swallow has turned the rote ironies of 1980s and '90s 'commodity critique' inside out by slipping into the space between the hand-made and the machine-made, and secreting time inside mass-produced objects. His initial guides in this endeavour were not orthodox appropriation artists or their academic pit crews but subtler and more generous practitioners. A short-list would have to include Richard Pettibone, whose exquisitely crafted copies of Duchamp's works are seminal examples of the 'hand-made ready-made'; the Swiss art duo Peter Fischli and David Weiss, whose rubber casts and hand-carved reproductions of studio debris were on Swallow's mind from art school onward; and painter, print-maker and occasional sculptor Vija Celmins, who applies such a pressure of scrutiny to mundane scenes and objects that sensations of awe ensue.

True fakes, authentic reproductions. Three remarkable sculptures from 1999 and 2000 raise the tension between the hand-made and mass-produced to a new pitch. The group, which Swallow jokingly calls his 'white album', consists of a sculpture of

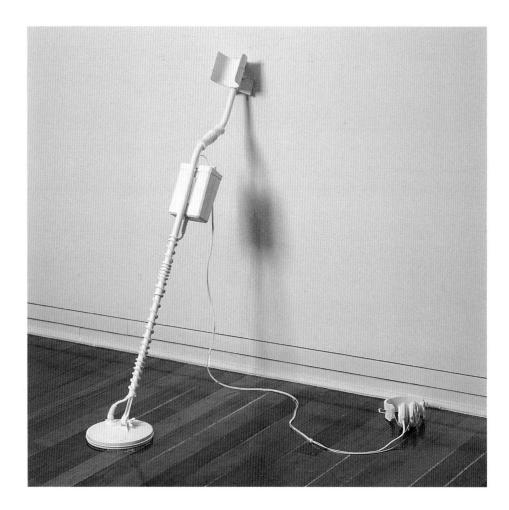

Diagonal Choir 2000
plastic, PVC pipe, epoxy, spray paint
111 x 78 (from wall) x 21 cm
Collection of Warren Tease
and Katherine Green, Sydney

Diagonal Choir, detail 2000
plastic, PVC pipe, epoxy, spray paint

Peugeot Taipan, Commemorative Model (Discontinued Line) 1999
studio production shot, 200 Gertrude Street, Fitzroy

Facing page:
Peugeot Taipan, Commemorative Model (Discontinued Line) 1999
PVC piping, PVC sheeting, milliput, airbrushed stone white automotive paint
scale 1:1
Courtesy: Darren Knight Gallery, Sydney

a BMX bike (*Peugeot Taipan, Commemorative Model (Discontinued Line)*, 1999), a telescope (*'The Stars Don't Shine Upon Us, We're in the Way of Their Light' (Family Telescope)*, 2000), and a metal detector – the beautifully named *Diagonal Choir* (2000). Together they make for a bare and wintry spectacle, as if a suburban rec-room had met with a new ice age. There's something blazing, almost devotional, about Swallow's patience and concentration in these works. He crafted each component from epoxy putty and PVC and then sprayed the final objects into monkish whiteness. To see the sculpture of the bike, for instance, beside the oil-clogged original (salvaged from a friend's garage) is to register the full, vampiric weirdness of the makeover: chain-link by chain-link, Swallow steals the object back from the world of rust and use into some untouchable, pre-dirt state. The absolute absorption in superfine detail suggests the doggedness of this attempt to repossess the past: *I remember this, and this, and this.* At the same time, the sculptures' brittleness and fragility (these are

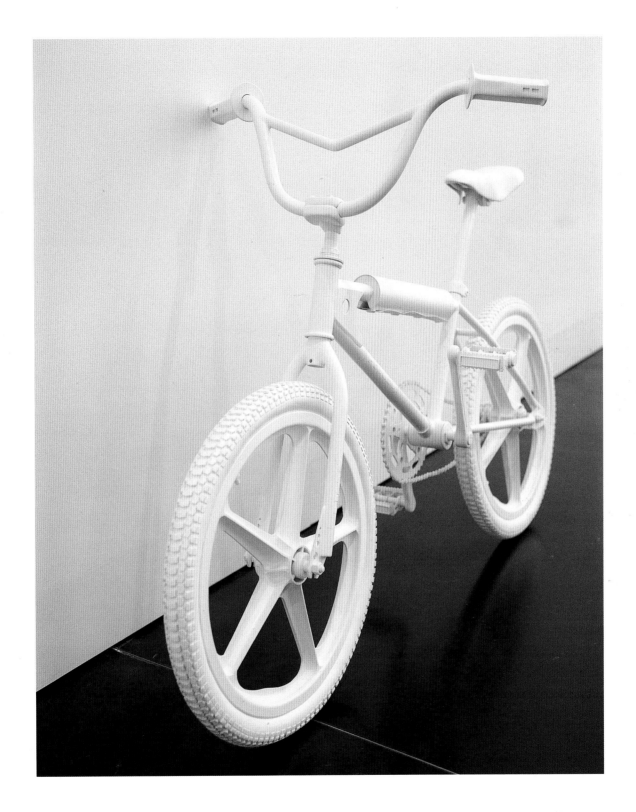

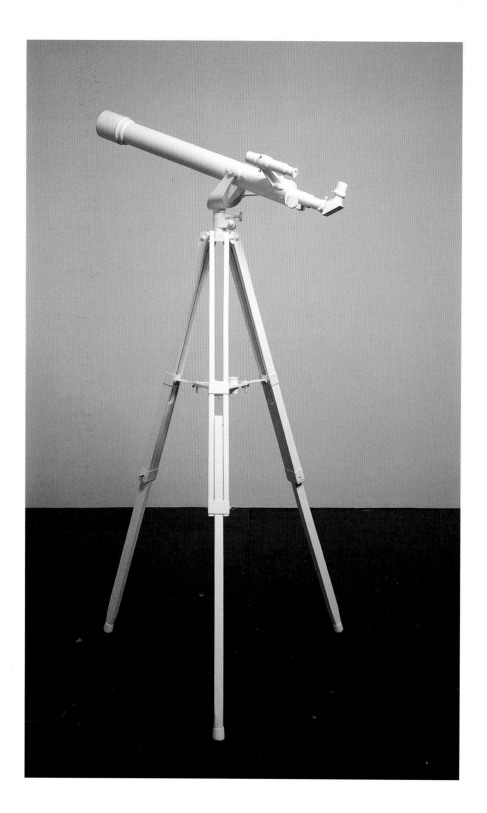

works that strike fear into the hearts of conservators) testify to the impossibility of total recall.

The sculptures are a sustained rebuke to what we might call the see-and-get reflex – the assumption that a sculpture will yield up its significance as swiftly as a graphic image. Whenever a viewer walks right past one of these sculptures (as a few do), on the assumption that Swallow has merely spray-painted a functional object, they stroll directly into the trap that the works lay for impatient viewers. What look at first glance like found objects turn out, on closer looking, to be fiercely hand-made objects in Duchampian camouflage. The sculptures occupy the same amount of space as the actual objects, yet the effect of Swallow's labour is to open a crack of time between copy and original that is large enough to get lost in. The whiteness is crucial. On one hand, it turns the objects toward the past (they could be monuments, pale and stony). At the same time, it tilts them toward the future (they could be industrial models or prototypes, awaiting mass-production's kiss of life). In this way Swallow joins the beginning and ending of the product's life, and suspends it in an uncertain present. These sculptures inhabit a kind of clearing in the traffic of objects, where things that have forgotten when and where they are wait to have their fates decided.

Like the *Vacated Campers*, all three sculptures are very closely haunted by an absent operator, who may or may not be Swallow himself. In its original form, each object promised to shrink distance and conquer time. The bike took kids out through the suburbs to whatever lay beyond. The detector offered secret knowledge of an underworld of objects. And the telescope brought unseen regions of the sky into view. In Swallow's recreations, these promises have been frozen. The detector channels nothing but silence; the bike would hardly support a ghost. This tension between art and other spaces – between the object and the distances it once accessed – is at its most acute in the sculpture of a telescope. What happens when vision is blocked or impeded? The will to see is intensified. Like Jasper Johns's bronze *Flashlight* of 1960, Swallow's telescope negatively illuminates what art has stopped it doing. He has twice installed the sculpture near a window, so that viewers register the full perversity of its 'blindness'. It's as if all the distance the real telescope might have accessed has been drawn down and locked into this object. Finally, *'The Stars Don't Shine Upon Us, We're In the Way of Their Light' (Family Telescope)* is a kind of charm: a laborious

Facing page:
'The Stars Don't Shine Upon Us, We're In The Way Of Their Light' (Family Telescope) 2000
PVC pipe, plastic, epoxy putty, spray paint
scale 1:1
Monash University Collection, Monash University

attempt to calm or tame the shuddery vastness it points to. It is hard to imagine a bet-
ter monument to whatever fluke of physics put us here, in this light, in this room,
with this object.

A QUIETER PLACE

Call them exhibits from the Museum of Thwarted Communications. We see very
clearly that the white sculptures have been made with purpose and care. And at the
same time we're left to wonder exactly what they are made *for*. The works are tensed
between two dreams of sculpture's connective power: between the bliss of solitude
and the dream of contact, between taking you out of the world and taking you to
it. The paradox has special force in Swallow's case because the fabrication of the
works, the hours he pours into them, implies a love of solitude and also an excessive,
semi-spiritual faith in these objects.

‘Solitude’ and ‘faith’ are words one keeps backing into when thinking about *I Don't
Want to Know if You Are Lonely/Henry Feinberg's Communicator*, one of two works in
balsa wood from 2001. A feat of hobbyist skill, the *Communicator* is a reconstruction
of the device built by the alien in Steven Spielberg's 1982 film *E.T.* In scenes that distil
Spielberg's brand of suburban transcendentalism, the extra-terrestrial, lost on earth,
‘phones home’ with a communicator cobbled from domestic discards: a fork, a battery,
a Speak & Spell. An interstellar CB radio, a string-telephone to the stars, this piece of
do-it-yourself assemblage art understandably lodged itself in Swallow's memory.
Appropriately, then, Swallow's title gives credit not to the saucer-eyed gruesome-cute
alien, but to Henry Feinberg, the science and technology expert who made the origi-
nal communicator (the device worked, and now resides in the Chicago Museum of
Science and Technology). Swallow thus retrieves this object from the fictional world
of the film, returns it to its maker, and pays homage to unsung sculptors and salvage
artists everywhere. ‘For me the work is about … the promise of communication and
returning home …’, says Swallow. ‘The desire to communicate and the strange inven-
tions born from this need.’[4]

There is a utopian tradition within twentieth-century art – Beuys's devices are its
most famous products – which casts the art object as a conduit, a transmitter, a point

of contact between artist and world. Using a prop from a movie to discuss the potential of art underlines the melancholy silence of sculpture at a time when its old communicative powers have passed, for better or worse, to model-makers, film directors and set designers. What kind of instrument is a sculpture now?, Swallow seems to ask. What distances can it cover? He sends the retrieved communicator back into the world as a prototype for an undisclosed kind of communication, perhaps between humans who feel lost on earth. The title is crucial in summoning a tone, an atmosphere. Marcel Duchamp called the titles of artworks 'invisible colours', and the phrase perfectly describes the way Swallow uses titles to wash his monochrome objects with a glow of feeling.[5] Lifted from a song by American band Husker Dü, the sentence 'I don't want to know if you are lonely' shifts us from galactic distances to personal ones, and suggests that the latter can feel as large as the former. A communicator should *communicate* something, after all, but the balsa wood muffles all signals in a surface both numbed and vulnerable. Who exactly are the 'I' and 'you' of the title? Feinberg, or the artist, or perhaps his needy audience?

In his second sculpture in balsa, *Silence Kit/Upturned PowerBook* (2001), Swallow takes tender revenge on an object that connects but also binds the artist to the world – his portable computer. Thanks to the anthropomorphising cleverness of their designers, personal computers can be told to 'sleep'. Swallow goes one better by forbidding this computer to wake up. He carved his black Apple PowerBook lap-top from a single slab of pale balsa and presented it flipped, like a dead crustacean. The book will never open – it was 'made shut' – and the 'dead' mouse lies on its back alongside. (Swallow has always devoted special attention to the undersides of products, as if some weakness or secret might be encoded in their stoppers and access panels.) Nearly weightless, and almost soapy in their smoothness, both objects are interred beneath a tinted Perspex box. When Claes Oldenburg released a typewriter into a dream-like droop, in a famous fabric sculpture from 1963, he evoked a fantasy of slack-jawed incoherence, of language gone soft and sensuous. The *Upturned PowerBook* gives shape to a harder dream – lock-jawed silence, total shut-down. 'I was imagining my life without it', Swallow says, 'a simpler life, a life without such connection, before talking. This attracted me at the same time as concerning me, as this space I was thinking of was also a lonelier space, a quieter space'.

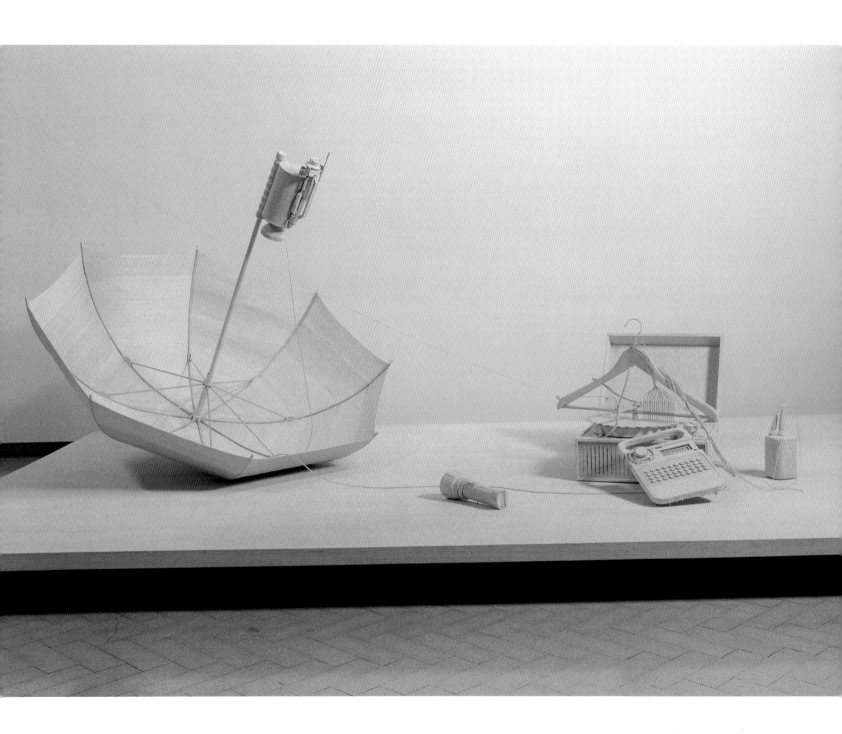

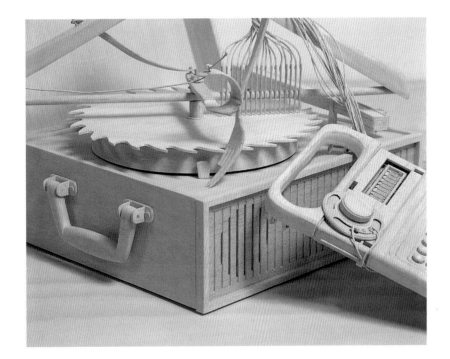

I Don't Want to Know if You Are Lonely
/Henry Feinberg's Communicator, detail 2000
balsa wood, plaster, string

Facing page:
I Don't Want to Know if You Are Lonely
/Henry Feinberg's Communicator 2000
balsa wood, plaster, string
250 x 95.8 x 150 cm
Vizard Foundation Art Collection of the 1990s.
On loan to the Ian Potter Museum of Art,
The University of Melbourne, Australia

Swallow is less interested in how loud an artwork can speak than how closely it can make you listen. It could be argued that every sculpture he has made is a silence kit: a potential space of quietness carved into the surrounding noise, with all that that implies of meditative solace and worrisome remoteness. The thought is supported, oddly enough, by the only objects Swallow has made that actually produce noise: the hand-built portable turntables from 1999 and 2000 that together form *The Multistylus Programme*. With their spindly tone-arms, polystyrene cup 'speakers', and portable-keyboard legs, these contraptions are closer to trembling hobbyist projects than to the whirring efficiency and whumping bass of contemporary audio equipment. The kind of performance they promote is pointedly quiet, almost anti-social. They draw you in and direct attention to the basic principles of analogue sound: the grooves of the vinyl record coming up through the needle to the polystyrene cup and on out to us in tsk-tsk-tsk vibrations. Swallow calls them Demonstration Models with good reason. Against the cliché of the DJ as a guru with crowds at his fingertips, Swallow's rustic sound-systems propose a humbler, first-person encounter, an intimate acoustics. When Swallow calls the console a device that 'allows you to spend time alone more freely', he is describing a practical fact – the *Multistylus* works are a straightforward delight to operate – but it is also possible to hear in that phrase one working definition of art.

A BRIEF HISTORY OF SKULLS

'Whether you want it or not. Everyone has to have one. 1641–1703.' So says the caption on a Raymond Pettibon drawing of a skull.[6] Swallow isn't arguing. Skulls stare out from almost every compartment of his work. To stare back at them is to get close to his sense of what a sculpture is. 'I think of the skull as a perfect form in some respects', he says. 'The simplest word or unit to describe or illustrate a used-up time or history, a spent thing.' In correspondence, Swallow sometimes alters the word's spelling ('scull'), as if to underline the idea of a skull as the thing sculpture starts with – a basic form, a primary structure. From the little resin skulls in *Evolution (In Order of Appearance)* (1999) to his more recent carvings in wood, he has meditated on what 'everyone has to have', and on the life it leads when 'you' are gone. After all, we are

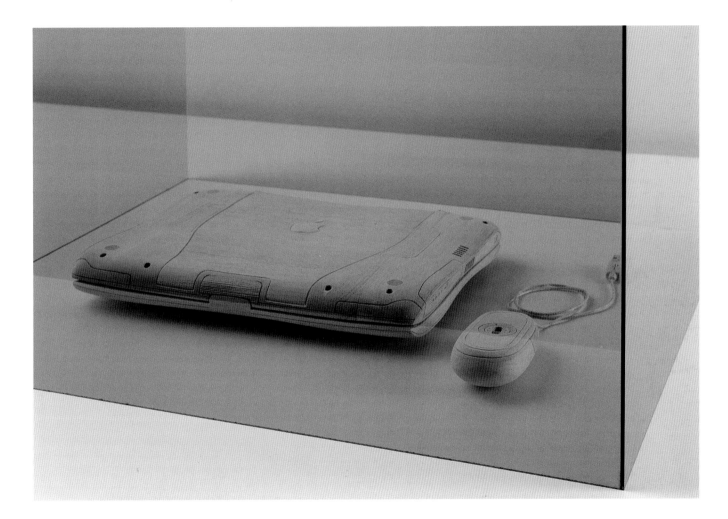

Silence Kit / Upturned PowerBook 2001
balsa wood, plaster, coloured perspex
61 x 139 x 52 cm
Collection of Warren Tease
and Katherine Green, Sydney

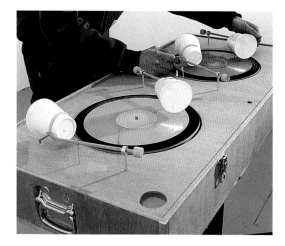

The Multistylus Programme 1999
functioning prototype
plywood, aluminium, hardware,
styrene cups, turntables, records
Chartwell Collection, Auckland Art Gallery
Toi O Tamaki, Auckland, New Zealand

Right and facing page:
The Multistylus Suite 2000
plywood, aluminium, styrene cups,
turntables, records
variable sized installation
The Michael Buxton Contemporary
Australian Art Collection, Melbourne

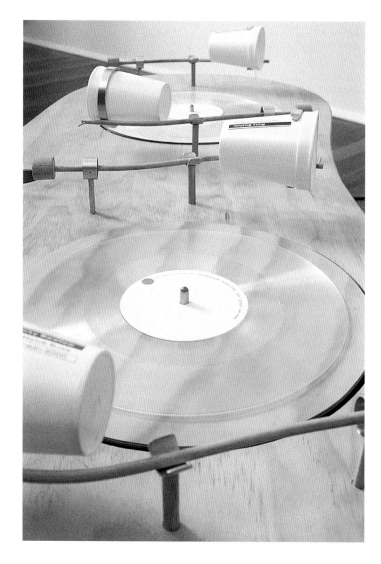

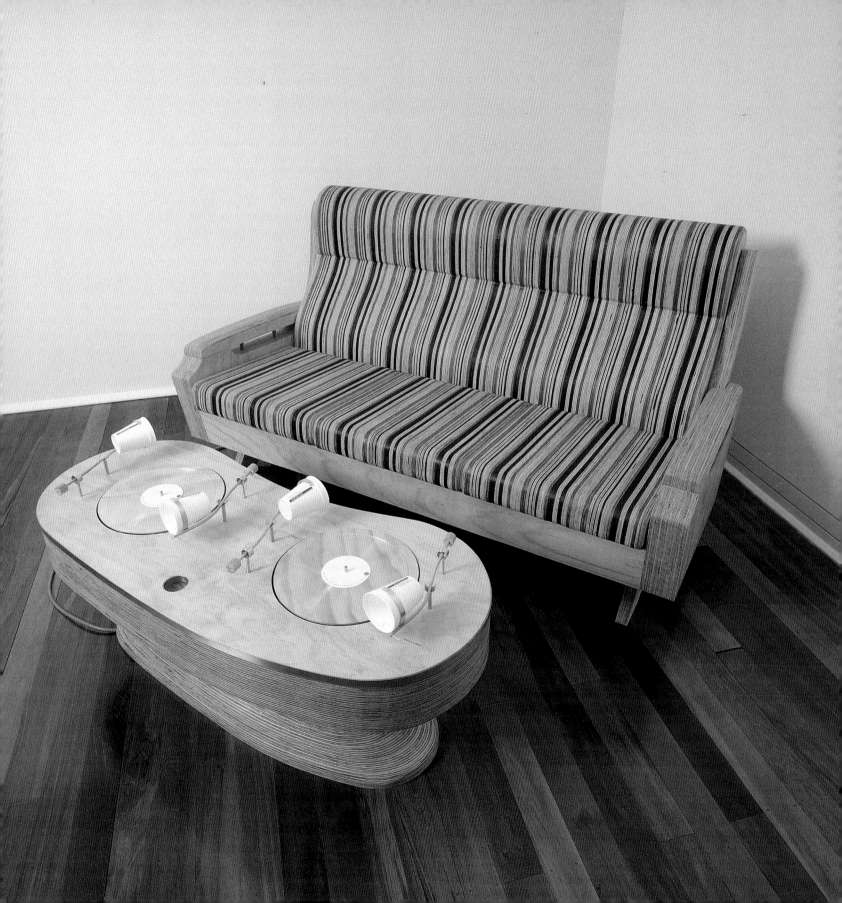

dealing with a sculptor obsessed by objects, and skulls, by outlasting us, make it clearer than any other object that we are objects too. This is not a new intuition (anyone who wants a dose of it can confront it in a mirror – just concentrate hard on the teeth), but in Swallow's hands it has fresh force.

Swallow has been attracted especially to the anarchic, undead energy that skulls and skeletons exude in popular culture, from the hipster zombies and skeletons in any number of rock videos to the hell-raising, die-hard skaters on Powell Peralta skateboard decks, which he places 'among the most stubborn images in my subliminal source book'.[7] The skull key-rings in *We the Sedimentary Ones/Use Your Illusions, Vol. 1–60* (2000) fondly invoke low-rent trophies such as Phantom rings, death's-head suicide knobs and above-the-dashboard danglers, and at the same time have a plausible meditative purpose as pocket-sized *vanitas*. In fusing the stylish and the deathly, they also recall the tiny ivory and boxwood Netsuke carvings of skulls and skeletons that some nineteenth-century Japanese gentlemen wore on their waist ropes. What results are sixty vivid droplets of studio duration, souvenirs of time taken from the artist. There is a skull for every second in a minute, and collectively they imply a chattering incantation: *nature morte, morte, morte, morte …* In a later 'edition' of this work, the skulls, grouped on the flat rather than hung on a wall, look like a pod of grinning hand-grenades in designer war-paint.

But it's as a structure more than as a symbol that the skull attracts Swallow. When, in 2000 and 2001, he cast his first 1:1 resin models of a human skeleton, the endeavour had an air of self-education about it; model skeletons are used as teaching aids in medical schools, after all, and they once hung around in art schools too. One sensed that the artist was submitting himself and his viewers to a deeper schooling in how we fit together. Both of Swallow's skeletons offer indelible images of humans who have run out of time; he calls them 'final moment portraits'. In *The First One Now* (2000) a skeleton fails to climb a ladder fast enough; it sinks thigh-bone deep in a pool of itself. *For Those Who Came in Late* (2001) likewise gives us the residue of some hard and final struggle, in which a human, who clutches another human's thigh-bone, seems to have taken shelter beneath a park bench and got himself stuck. The flesh and wood have rotted away, leaving only the skeleton trapped by the 'skeleton' of the bench. By action-painting loops of green and brown resin into the open

Facing page:
The First One Now, detail 2000
pigmented resin
Courtesy: Darren Knight Gallery, Sydney

moulds before closing them and pouring in the white, Swallow wrapped both skeletons in a web of graphic energy. They look scribbled on – or perhaps scribbled out – in a crackle of final writing. (I like to think of the Pollock-like puddle in *The First One Now* as a sculptor's knowing side-comment on the old hierarchy between sculpture and painting: here painting is the primal soup from which sculpture tries to rise.)

The effect of these works is partly, grimly, comic; they recall cartoons of cobwebbed skeletons with their hands stuck in Coke machines. But they are also attempts to articulate, in three dimensions, hard-to-describe physical intuitions. Is the skeleton 'us', or the thing on which 'we' are draped? Is sculpture a terminal condition? Should we try to out-climb it, or take it lying down? Smaller sculptures from the same year attempt to trap and contain these paradoxes. In the turntable piece *Another Endless Excavation* (2001), a giant device (based on the tone-arm mechanism beneath) endlessly drills for clues inside the geology of a half-excavated giant's skull – a helpless aural witness to its own undoing. *Placement Sculpture (Skull in the Wood)* (2001) likewise arranges a strange marriage between the body and the objects around it. A cross between an ossuary and domestic display module, it wedges a jaw-less resin skull inside a wooden version of the bench form in *For Those Who Came in Late*; the lines of the resin strata run parallel to the lines of lamination in the wood. The skull is now trapped by what once supported it. Very deliberately (the word 'placement' carries weight here), the piece shows Swallow feeling for a fiercer knit, a denser composite, of body and surround. The look of that composite declares itself in 2002, when Swallow turns to a new medium, and another kind of excavation.

'NOT A STILL LIFE BUT A SLOW LIFE THEN'[8]

The choice to work in wood could seem odd for a sculptor who only a year earlier had overseen the computer-aided injection-moulding of a set of hi-tech skulls, and who belongs to a generation that reserves special dread for 'twig art' of the Andy Goldsworthy variety. But it fits with the larger arc of Swallow's career, which has been a series of sustained, hands-on encounters with materials of increasing resistance – cardboard, then resin, and now hardwood. This is, partly, a matter of daily pleasure; Swallow gets bored fast in the studio if there is nothing to be learned. More than that,

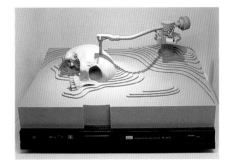

Another Endless Excavation 2001
resin, turntable, plastic, spray paint
44 x 37 x 25 cm
Collection of Warren Tease
and Katherine Green, Sydney

Facing page:
*Placement Sculpture
(Skull in the Wood)* 2001
plywood, pigmented resin
74 x 65 x 16 cm
Barber/Cottier Collection, Sydney

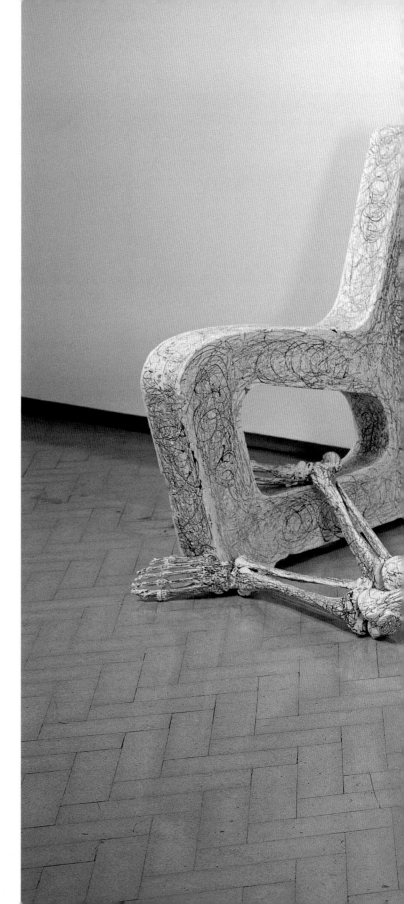

For Those Who Came in Late 2000
pigmented resin
80 x 150 x 70 cm
Collection of Christopher E. Vroom, New York.

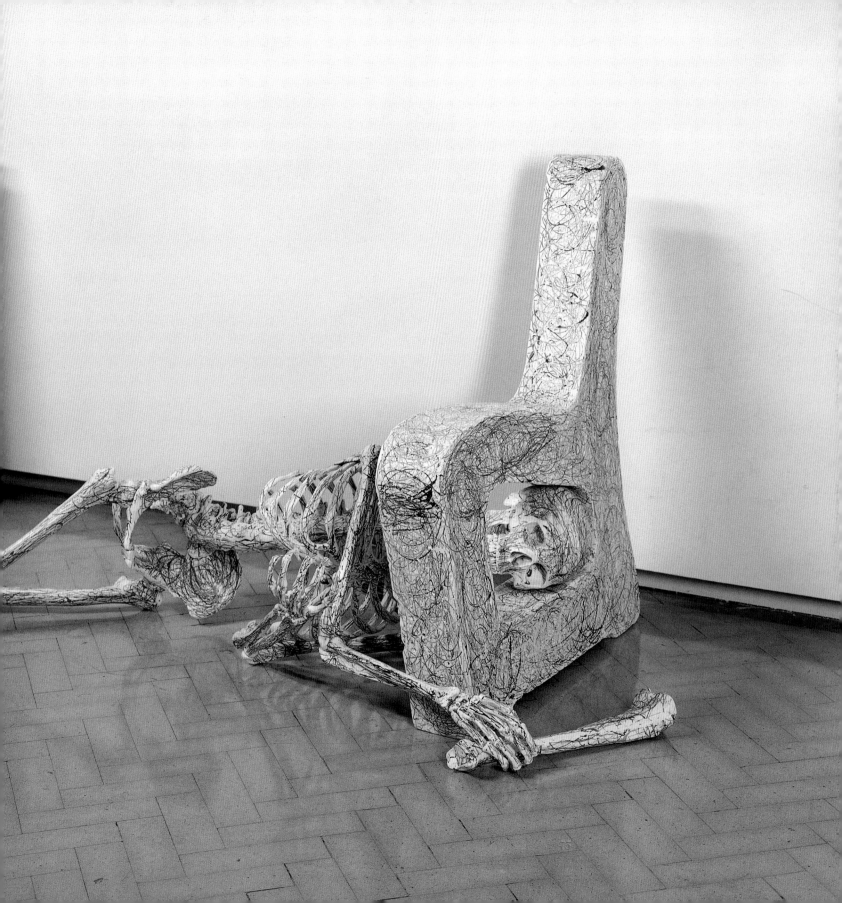

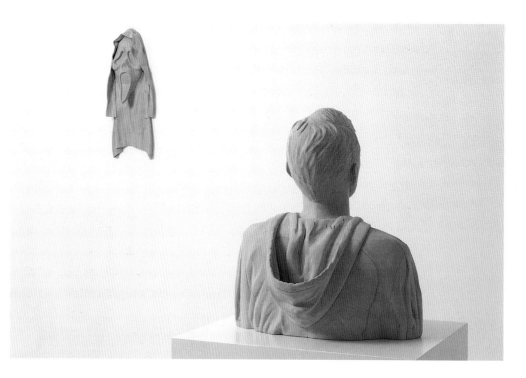

Wooden Problem 2002
Installation view, Karyn Lovegrove
Gallery, Los Angeles

wood allowed him to test his faith in the relation between the time taken (by the artist) and time given back (by the audience). Wood gave him a way to achieve harder proofs, a crisper absence. It ensured that every detail was *earned*.

Each medium has its own distinctive stresses and speed limit. Resin, for instance, has a glib certainty: thirty minutes in the mould and it's mimicking the permanence of stone. By contrast wood is slow, and its memory is long; time is there to read in its fibre. As Swallow learned in Belgium in late 2001, it also has a long cultural memory. In Ghent to take part in the group show *Casino*, Swallow had been stopped and silenced by some wood-carvings in the Bijloke Museum – chief among them an unpainted still-life tondo from the early eighteenth century by Laurent van de Meulin. Its hoard of skulls, fish, arrows, lacework and fruit appeared less to have been carved than to have grown into shape. It was the coralline strangeness of the carving that held Swallow, the absolute tension between illusion and material. The objects seemed at once to subdue the wood and to be trapped by it: locked in. Here was the tense calm that Swallow sought in his own work, but raised to a new power. For an artist eager to

measure contemporary objects against larger time-scales, and thus reboot the still life, wood seemed the right material to turn to.

Wooden Problem proved it. Shown in Los Angeles in mid 2002, shortly after Swallow's move to that city, *Wooden Problem* was a five-sculpture meditation on what is left when someone goes.[9] Entering the show viewers didn't tower over small worlds but rather walked among things their own size, everywhere conscious that they duplicated objects that the artist once had alongside him. A bird nested in an abandoned shoe. A mask hung on the wall. A stool supported an apple core. A skull was thrust in a beanbag. And a portrait bust listened in nearby. Carved from jelutong, a soft, straight-grained hardwood, the wooden sculptures have a colour that is also a texture; they give and take a distinctive light. At first, detail is hard to read in the powdery, dune-coloured surfaces, and the objects seem to haze a little. Step closer and this softness yields to Swallow's hallmark effect of high fidelity.

Sculptural realism's paradoxical power is to conjure presence in absence, lightness in weight, the softness of flesh or fabric in stone or wood. *Come Together* (2002) is Swallow's hard-core homage to Baroque realism and its apparitions of the soft in the hard. Rudolph Wittkower's big book on the Baroque master Gianlorenzo Bernini is never far away in Swallow's studio, and *Come Together* is a knee-high tribute to the meeting of skull and baldachin in Bernini's *Tomb of Pope Alexander VII*. Call it a rec-room entombment. The bag sits there in a frozen slump, on initial viewing no more than a banal, 1970s suburban object, and you need to get close to see the embedded skull. You don't see it, though, so much as take its weight; it's an indisputable object. The first impression of a plummeting impact – the skull winding the bag like a meteorite – is pushed back by the illusion of a geologically slow entrapment from below, as if the bag grew into shape around the skull.

In this, the second carving he made, Swallow seems torn between the attempt to renovate the *vanitas* still life in all its pathos, and the impulse to mock the seriousness of that attempt by burying the skull in its own plinth. Since the seventeenth century in Holland, a time and place newly glutted with objects, still life has been used to calibrate the life of things and the lives of those who own them – to measure shelf-life against after-life. Four hundred years since the genre's heyday, in a period so design-drunk and object-fetishising that it makes gilded-age Amsterdam look frugal, Swallow

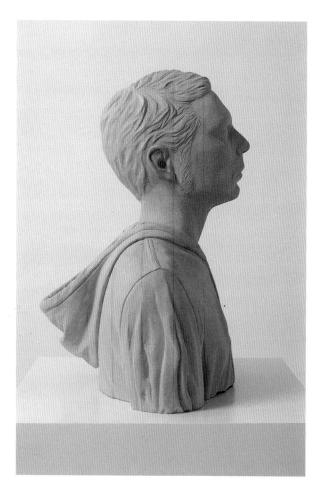 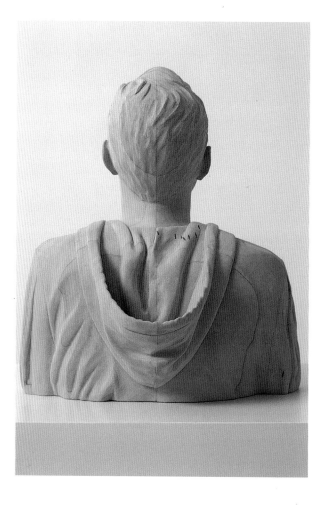

Above and facing page:
And the Moment Will Come When
Composure Returns (Decoy) 2002
laminated jelutong
54.25 x 49.25 x 35.25 cm
Collection of Samuel and Shanit Schwartz, Los Angeles

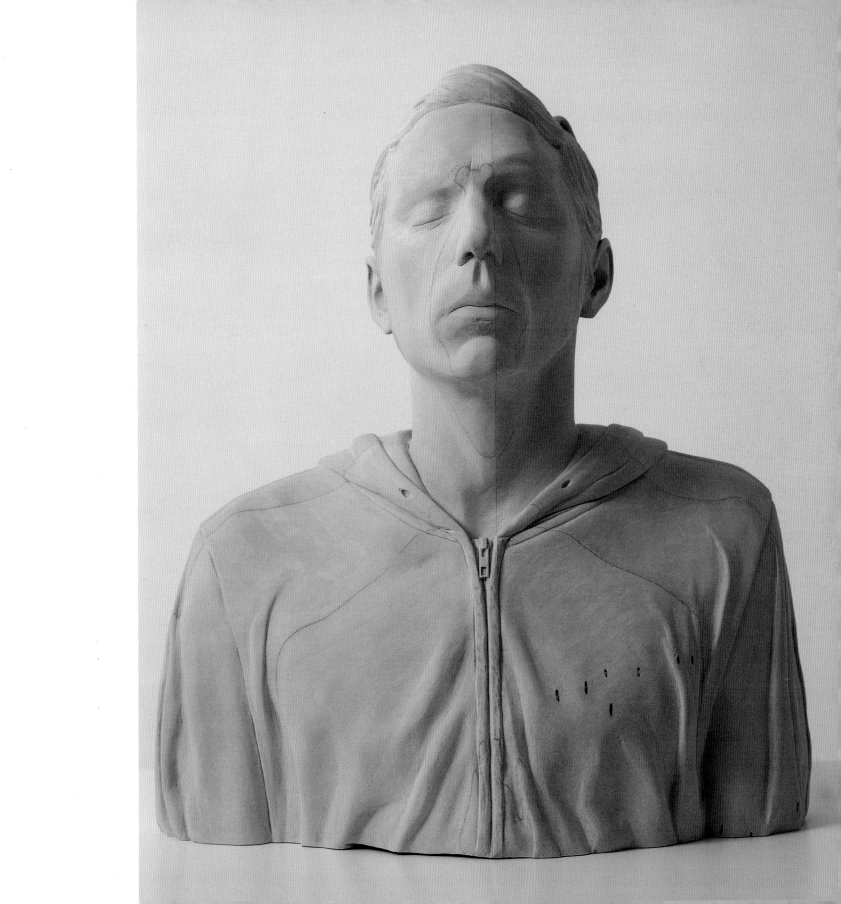

began to import his cargo of lifestyle objects into wood's peculiar time-zone. When, for instance, he recasts the stretched skull of the *Scream* movie mask as a relief sculpture – *Ask Me About My Feelings* (2002) – he seems to be testing the viability of the *vanitas* today, measuring the distance between Holland and Hollywood.

To walk into *Wooden Problem* was to step inside a life-sized still life, but one whose contents had been subjected to a riddling rearrangement. Someone has dropped in and altered the order of things before quitting the room. *Fearful Symmetry (Caroma/Core)* (2002) is a carving of a modular plastic stool, a 1970s rumpus room totem that wants to be a plinth or a monument. But whatever was meant to be enshrined on it is gone, and whoever toppled or stole it has left a souvenir in the form of an apple core placed just so; its gnawed-down shape mimics the stool's. Having encountered bitten apples not so long ago in Swallow's work (*Apple 2000* and *Apple B/W 2001*), it seems fair to take the core as a calling card deposited by a sly escape artist, and to see the entire sculpture as a self-portrait *in absentia* – the latest of what Swallow has called his 'evaporated self-portraits'. We feel the trickster-artist's off-stage presence again when, in the work *Together is the New Alone* (2002), Swallow places a sculpture of a bird in a sculpture of a shoe, with all the fastidiousness of someone setting a trap. It is, in fact, a sculpture of a sculpture of a bird – Swallow's copy of a hobbyist carving – which only heightens the suspicion that we're being duped.

The rumours of doubling and disappearance converge on *And the Moment Will Come When Composure Returns (Decoy)* (2002). It is a self-portrait bust of Swallow in a very Franciscan-looking hooded sweatshirt (imagine Zurburán designing menswear). The eyes of sculptured portraits are usually closed only in death-mask casts (Napoleon, Ned Kelly) or in evocations of mystical transport (St Teresa ravished by God, Jeff Koons ravished by himself). This sculpture presents a state less grand than death or rapture: it gives us Ricky Swallow in shutdown mode, a portrait of the artist in a state of pause. Swallow observes a cardinal rule of art. Secrets play better than confessions. The self-portrait has what might be called a generous reticence. Its withdrawal from the world draws you in.

And then – up close – the wood starts to tell us things that unsettle the sleeper's calm. A rubber tree, among the softest of the hardwoods, jelutong is a wood used by research and design teams to sculpt patterns for metal casting and prototypes with no moving

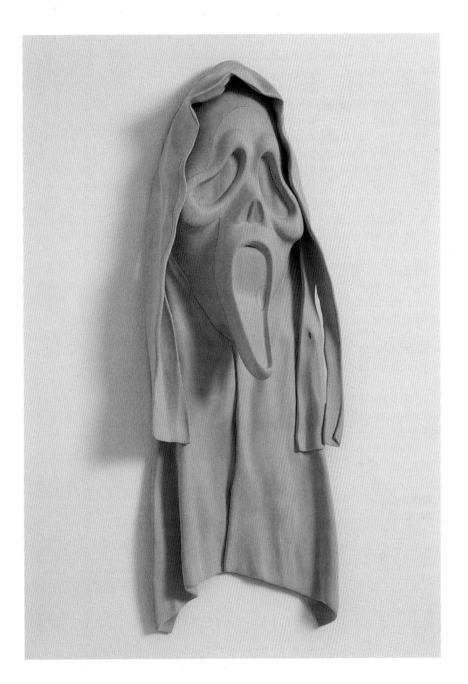

Ask Me About My Feelings 2002
laminated jelutong
50.4 x 22 x 6.5 cm
Collection of Bruce Harrison

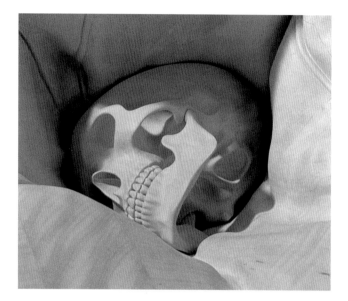

Come Together, detail 2002
laminated jelutong
66 x 63.5 x 81 cm

Facing page:
Come Together 2002
laminated jelutong
66 x 63.5 x 81 cm
Norton Family Collection, Los Angeles

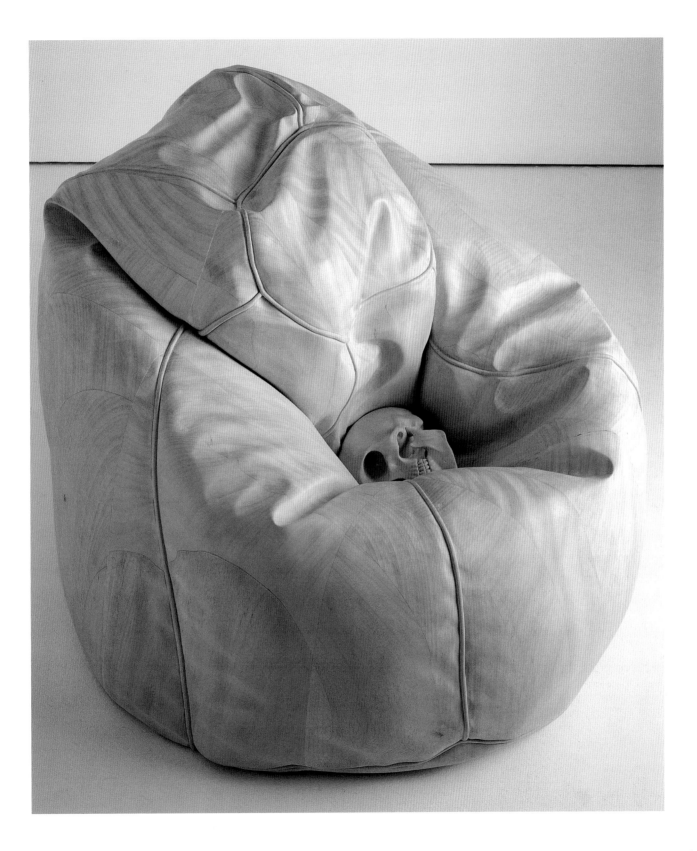

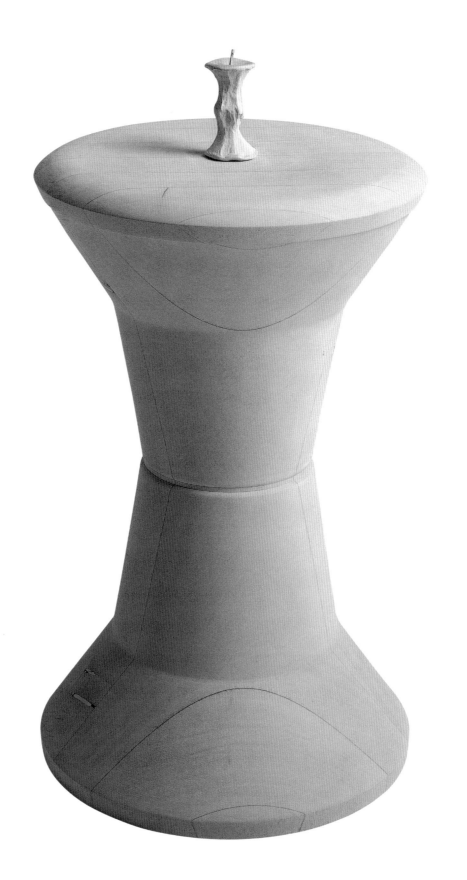

parts. 'Jelutong has the perfect blankness', Swallow says. 'It's beyond uninitiated or mute.' The block Swallow carved himself from was first laminated from smaller blocks, the grain reversed on every second slice. When Swallow goes to work with his gouges and chisels, the seams of glue between the blocks start to ripple and bend like lines on contour maps. The result is a strange tension. At a distance, this wooden boy seems as solidly and calmly built as a piece of Shaker furniture. But up close, where you can see the grain, the seams of glue, the ducts in the wood, there's an impression of something held together against the odds. The statue seems to contain the thought of its own fragmentation.

To encounter Swallow's self-portrait and briefly take the artist's place in front of it is to sense the full dimension of his 'wooden problem'. What is it? How to give the here and now weight. How to remember the present. Swallow attempts to make a memorial not to an epoch, a leader or a nation but to the moments of downtime we all live through, and he does so in the knowledge that such a monument is bound to fail. We can no more watch ourselves in the flow of the present than we can watch ourselves sleeping. No matter the technology with which we stalk the here and now – Handycams, diaries, DAT recorders, chisels, whatever – what these instruments finally provide are decoys and remains. The portrait bust feels less like a statue of Swallow than of the space where he used to stand, a contour map of some empty air.

It's too much, a visitor to *Wooden Problem* might have said, all this bait laid for critical sleuths and professional interpreters. But Swallow's still-life trap was more finely wired than that. In the face-off between the portrait bust and the mask, an odd transfer of energy took place. The silenced bust started to seem a little too perfectly 'poignant', and it dawned on you that this was an impersonation of a sleeping person – a pawn or decoy sent in to distract us while the sculptor was off somewhere else, coming to his senses. Meanwhile, the emotion drained from the self-portrait built like pressure behind the mask; it strained to say what the bust wouldn't. The genius of the original *Scream* mask's design is that it manages to look at once bored and fearful, or even bored *by* fear. (It could be called 'The Yawn'.) Passed from Munch to Fun World toymakers and then to Wes Craven, who made it the logo of his hyperconscious 1996 horror film *Scream*, the mask is a format so drained by sequels that it might be thought beyond reclamation. But by freezing the screamer in pale wood and sealing shut the

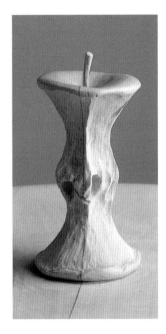

Fearful Symmetry (Caroma/Core), detail 2002
laminated jelutong
56 x 33 x 33 cm

Facing page:
Fearful Symmetry (Caroma/Core) 2002
laminated jelutong
56 x 33 x 33 cm
Collection of James and Jacqui Erskine, Sydney

black O of its mouth, Swallow creates a domestic gargoyle of unexpected pathos: a power object for the age of 'emotional block'. Together the mask and self-portrait tell a story about the attempt to speak plainly of 'feelings' at a time when even screams are quotations.

HERE AND GONE

Monuments carve out a space for memory. Something is gone, and to mark its absence we put something into the world. From the toppled Statue of Liberty in one of his post-art school sculptures to the molten Darth Vader in 1999's *Model for a Sunken Monument*, Swallow has wondered what kind of monument we might want – or deserve. There was good reason to wonder in September 2002, one year after the terrorist attack on the World Trade Center, when Swallow's exhibition *Tomorrow in Common* opened in New York. To ignore the memory would seem tactless, to make art directly about it could seem twice so. Swallow was not about to presume to do the latter: 'Although I was in a way trying to map disappearance', he says, 'it was of a much more private nature'. But, on a heavy occasion, he achieved something rare. He filled a small room with an exhibition about the weight of sculpture, and about how much memory sculpture can bear.

The works (all 2002) manage to seem at once lighter and heavier than they are. Lighter, because they appear as pale and parched as driftwood. Heavier, because they pull viewers down to meet them. All sculptors establish their own centre of gravity – high and hovering like Calder's, low and broad-shouldered like Serra's. Ever since he made his early sculptures of ground-hugging sharks and manta rays, Swallow's centre of sculptural gravity has been set low. *Tomorrow in Common* was something of a return to the sea-floor feeling of those early shows. Arrayed on the floor of the Andrea Rosen Gallery, the works – sleeping bag, a hat, a fish in a tyre – looked cast-up, beached. One imagined some lake or ocean draining away, and this silt-coloured sculpture garden gasping into view. Not an excavation so much as a surfacing; not a dig so much as a sink.

What surfaced here, as in *Wooden Problem*, was the evidence of someone's departure. In *Growing Pains (Contingency for Beginners)*, a pair of hands (Swallow's) blindly

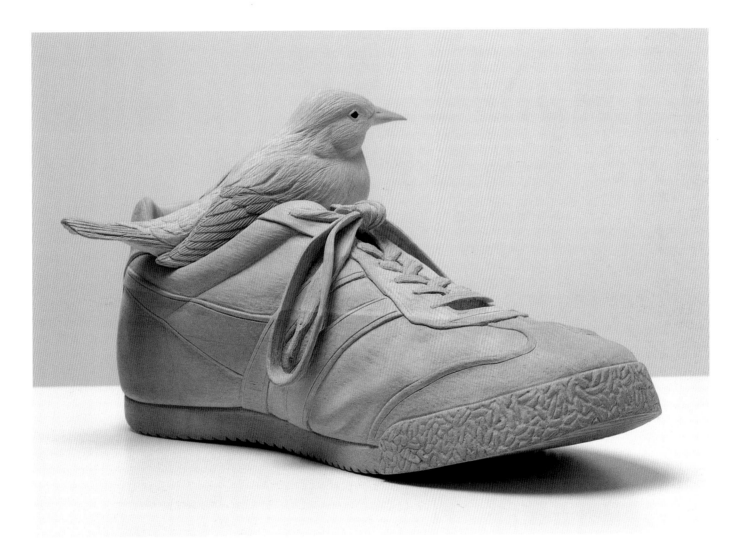

Together is the New Alone 2002
laminated jelutong, glass eyes, milliput
30.25 x 16.5 x 15.25 cm
Collection of Doug Inglish

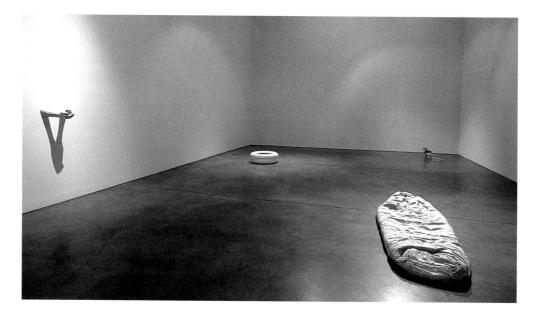

Tomorrow in Common 2002
installation view
Andrea Rosen Gallery, New York

reaches through the wall and weighs up the small change of survival: pills or beans, sleep or sustenance. *Sleeping Range* mummifies a nylon sleeping bag. In *Private Dancer*, what might be the last fish on earth lies in its terminal pond (a car tyre), sleek but utterly still. Perhaps the most fruitfully perplexing of the sculptures (*Instrument*) fills an upturned cap with a dead weight of chain (carved, in an old-time whittling trick, from one piece of wood). Is it sunken evidence? A human anchor? A busker's hat filled with some unlikely currency? The object refuses to be explained away; it tugs persistently at the mind.

Swallow observes what might be a cardinal rule for sculptural story-tellers. Bury half of the narrative, so that viewers feel compelled to complete it. The British writer JG Ballard has shown Swallow how to make narrative use of a certain distant and alluring dryness. With their inexplicable ruins and accidental monuments, Ballard's novels and stories are a declared influence on all of Swallow's sculpture and *Tomorrow in Common* especially. And there is another source, even farther back, for Swallow's unquiet objects (and Ballard's too). His bone-dry syntheses of unlike things – a fish in a tyre, a skull in a bag – descend from the un-still lifes of the Surrealists, in particular

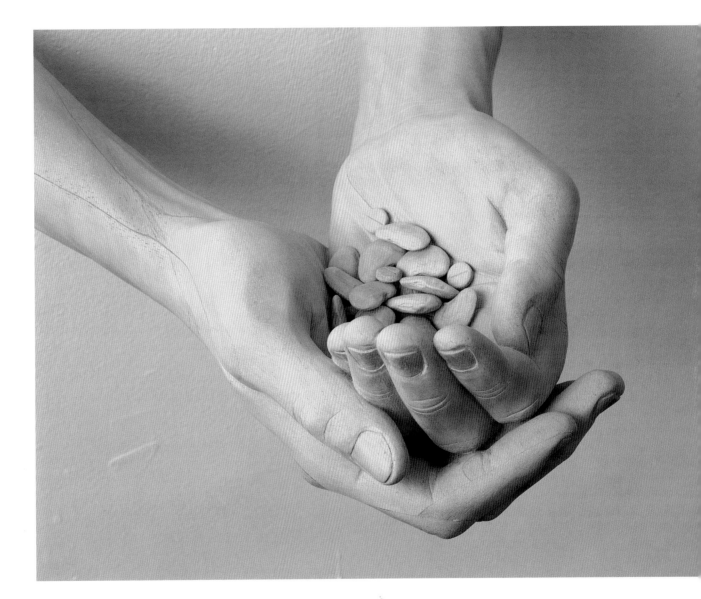

Growing Pains (Contingency for Beginners) 2002
laminated jelutong
30.25 x 26 x 10 cm
Collection of James and Jacqui Erskine, Sydney

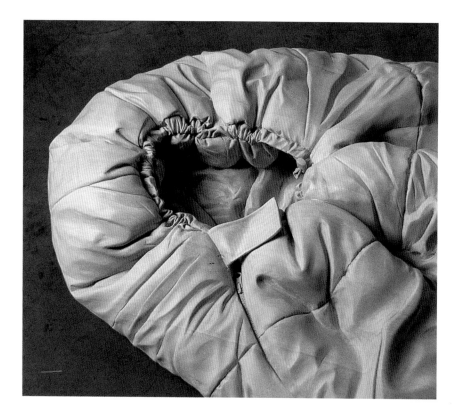

Sleeping Range, detail 2002
laminated jelutong

Facing page:
Sleeping Range 2002
laminated jelutong
198 x 71 x 20 cm
Lindemann Collection, Miami Beach

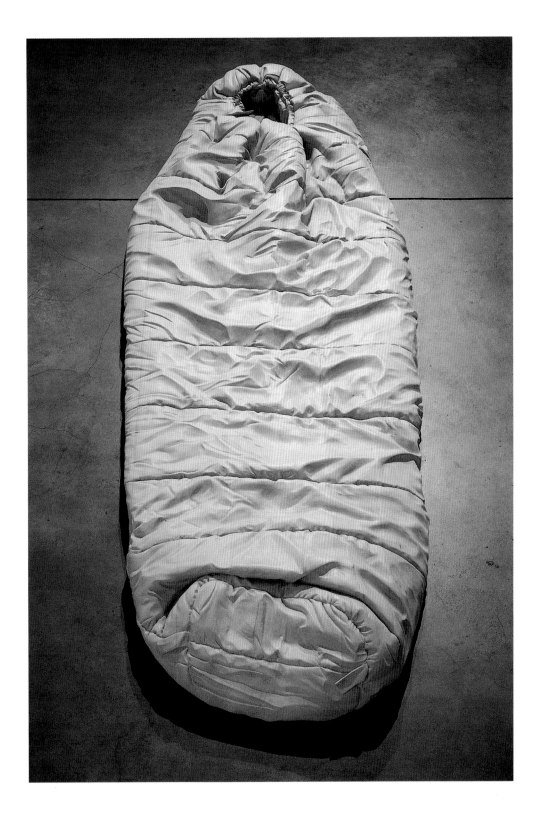

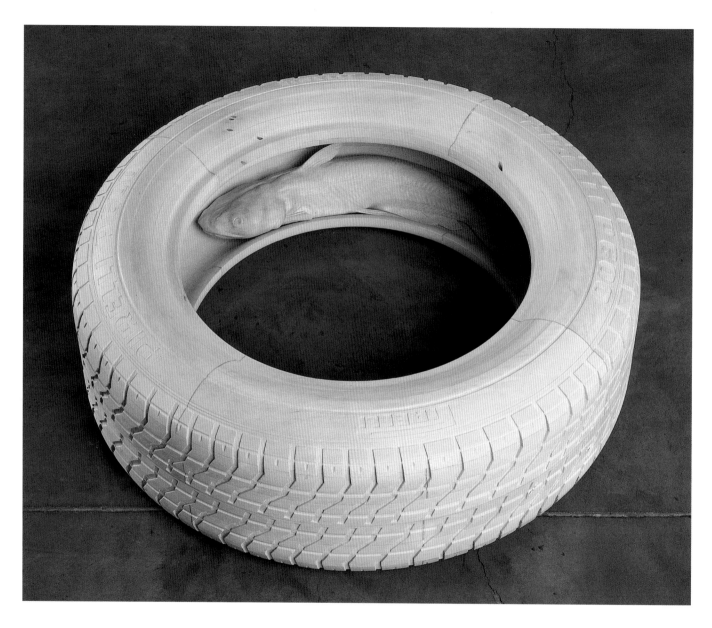

Private Dancer 2002
laminated jelutong
58 x 58 x 20 cm
Collection of Ivelin and Craig Robbins

from the fossilized landscapes that Max Ernst painted in the 1940s. The Surrealists saw that mass production had created an underclass of abandoned and obsolete objects, and an audience hypersensitive to the strangeness sparked when those objects were combined. Almost a century later, the heap of discarded objects that the Surrealists rummaged through has grown into an astonishing midden, and this landscape of forgotten things is where Swallow finds his forms. With its scavenged assemblage of saw-blade and umbrella, Swallow's 2001 work *Henry Feinberg's Communicator* is a twenty-first-century update of Lautréamont's famous image – a touchstone for the Surrealists – of 'the chance encounter of a sewing machine and umbrella on a dissecting table'. In *Tomorrow in Common*, Swallow gives us vignettes from a world of such 'chance encounters', and perfectly tunes the tensions between them.

Sleeping Range anchored the exhibition. One of the several large carvings that Swallow has worked on with his assistant Mike Conole, this life-sized sculpture of a vacated sleeping bag floods a low slab of hardwood with more expressive force than it ought to be able to contain. In Baroque sculpture, fabric often declares what the figure only hints at: think of the dreaming rafts and clouds of fabric that buoy up the figures on monuments such as Bernini's *The Blessed Lodovica Albertoni*. And Surrealism showed how perversely eloquent a wrapped form could be: think of Magritte's shrouded *The Lovers*, or the blanketed object in Man Ray's *The Enigma of Isidore Ducasse*. Swallow put this technique to work in his self-portrait bust from 2002, where the dream-life of the sleeping figure seems to rustle in the folds of his hood. In *Sleeping Range* the body is absent – emphatically *gone* – and the bag speaks for it. 'Speaks', however, is too mild a word for what happens in the dazzling passage of carving that describes the bag's opening. The fabric is drawn into a frozen cry as startling as the 'Scream' mask's is comical. The bag seems to gasp in astonishment at its own transformation into wood.

But there is another, fainter, illusion that ripples through the surface of *Sleeping Range* and undoes its tomb-like weight. The effect is so understated – the wood never stops being wood, the bag never stops being a bag – you could be forgiven for thinking it just a trick of the light, a daylight hallucination. But, seen from a low perspective or in raking light, the bag's creased, rumpled surface becomes a long island of rises, knuckling ridges, furrowed distances, all enveloped in a Death Valley dryness. Another

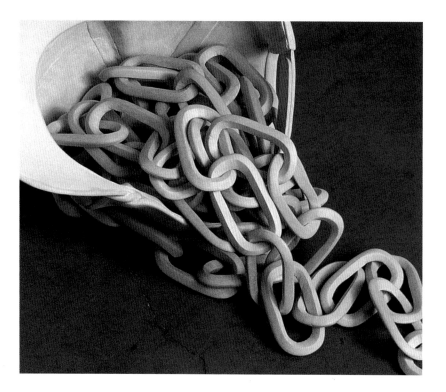

Instrument, detail 2002
laminated jelutong

Facing page:
Instrument 2002
laminated jelutong
28 x 16.5 x 6.35 cm

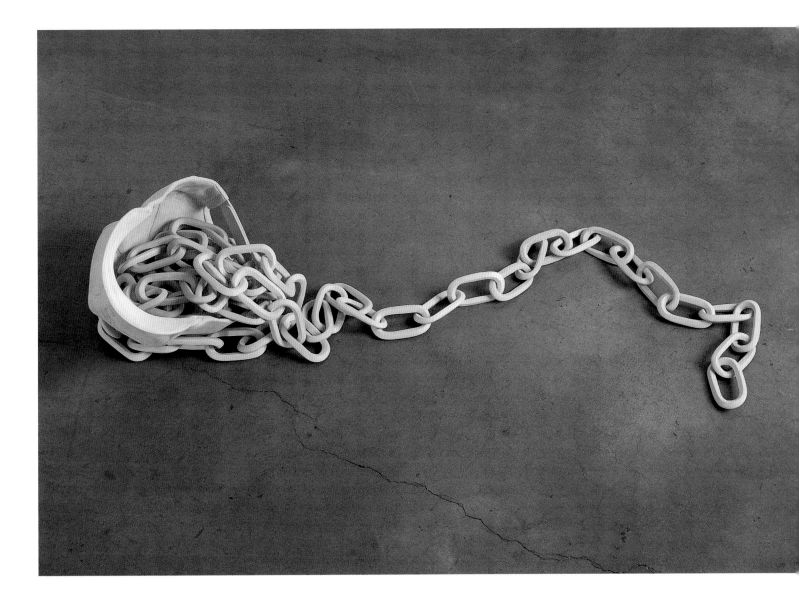

kind of 'range'. The clinching detail is the way the landscape plunges through that cratered opening into an unreachable interior – the sculpture disappearing into its own support. Swallow's achievement here is to coax from one shallow surface the expansive physicality of sleep and dreams – the flights and falls, the giddying changes of speed and state, the sense that the body might drift any place, or that the body is itself a place. *Sleeping Range* flickers with the force of these conversions. From fabric to marble to geology, from shelter to entombment to flight. Woodwork feels like dream work when you're close to this object, and looking becomes an act of discovery.

Rumours of statuary and monumental form keep stirring in the surface of Swallow's sculptures. His wooden boy wants to be as solid as a senator; his beanbag dreams of the tombs of popes; his sleeping bag looks like a toppled relief sculpture. But even as the height of their polish makes you think of marble, the wood holds the sculptures in a space of critical doubt. A baritone material, the stuff of History, stone was used by the makers of statues to grant their subjects geological permanence. Swallow's sculptures speak in a quieter voice. Yes, the four objects in *Tomorrow in Common* remember, or predict, some drought or crisis, but it is impossible to tell if it is an inner crisis or a social one, a matter of lifestyle or of life and death. Leaving viewers free to think of something as weighty as urban disappearance or something as light as a suburban sleepover, *Tomorrow in Common* located a space between private loss and public remembrance, and marked the space with monuments that are hesitant, pale, provisional. Thus the title, which can sound hopeful or bleak depending on your point of view. 'It's what connected the works', Swallow says. 'The fact that they had all the forgotten time left to just remain the same, be sustained in a final moment ...'

THIS VERY HOUR

By the time he began carving the objects in *Tomorrow in Common*, Swallow had set aside the multi-purpose drill (called a Dremel) that he'd used hitherto. And he'd expanded the seven or so chisels with which he carved *Come Together* into an arsenal of almost a hundred. Though mechanical lathes still play their part when a block is being prepared for carving, Swallow was, in his words, 'giving up all the faster methods for a want to once again flirt or even live with a tradition of carving, things like adzes

instead of chain-saws and using a combination of Japanese carving tools and pull-saws along with traditional Swiss/German carving chisels and mallets'. The results, as seen in the exhibitions *Roll Out*, *Field Recordings* and *Killing Time*, are some of the most intensely crafted objects in contemporary art. And that's the kind of innocent-sounding sentence that pitches us into what gets called 'contested' territory.

'Craft' is still a charged, even scandalous, term in the end of the professional art world that Swallow inhabits, inspiring nervous coughs from one quarter and sage grumbles of approval from another. In the twentieth century, modernist aversion to guild standards (too academic) and postmodern aversion to the mythology of the studio (too romantic) produced a view of craft-skill as a kind of excess in art's economy of ideas – something 'gratuitous'. (The accusation was often levelled at maverick wood-worker HC Westermann, an artist I like to imagine giving Swallow's recent sculptures a cross-generational nod of approval.) At the same time, industrial production tore apart the old equations that bound the time of the body to the time of things, and the machine entered the studio too. The fact that Swallow hand-carves his objects would, perhaps, be no more relevant than the fact that another sculptor prepares theirs by phone, if dividends weren't felt in the final objects. But they are – and *felt* is the operative word. Sculpture and architecture are at present so dazzled by the possibilities of digitally generated form that it gets forgotten that certain kinds of solid, certain registers of detail, can only be arrived at the hard way: all the CAD programmes and injection-moulding machines in the world are not going to produce an object as forensically vivid as the skull self-portrait, *Everything is Nothing* (2003).

Given the truth of Pettibon's claim that 'everyone has to have one', one of the oddest things about skulls is how poorly acquainted we are with their weight and shape; the form is usually encountered in two dimensions, as a logo or graphic motif. In his wooden skulls, Swallow has made it his business to get to know the skull from the outside in and all the way through: 'Seeing the skull as a thing with more accuracy and weight, more threatening detail, in those paintings and carvings from Bijloke Museum and the Prado told me I had to treat it with a different kind of analysis if I was going to use it in a way that had anything of the impact and stillness that I liked in its history', he says. 'Carving it is learning it, casting it is just having it there again.'

In its grimly witty face-off with the inevitable, the sculpture also connects to the

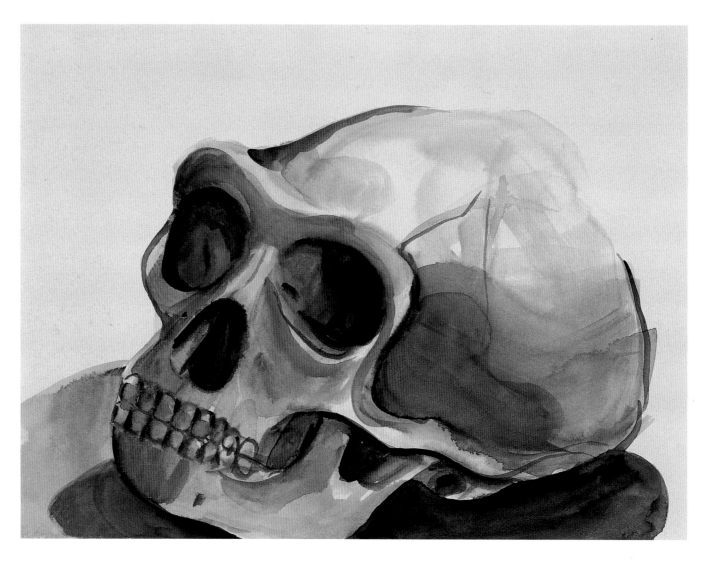

Skull 3 2001
watercolour on paper
28 x 38 cm

Death W/Candle 2003
watercolour on paper
24 x 13.5 cm

tradition of American folk-songs and tombstone images in which Death is not an abstract state but a real, clattering figure, all teeth and taunts, who delivers his gloating promises directly to, and through, the living performer. Among the lyrics on high-rotate on the studio CD player when Swallow was making this work was the following 'conversation with death':

I'll fix your feet so you can't walk
I'll lock your jaw till you can't talk
I'll close your eyes so you can't see
This very hour come and go with me

Think of the skull as a story that Swallow retells. When he carves that shared form, he's also reaching very physically into a history of carving: testing its depth, its tenacity, its viability. The process parallels the 'repetition of repertoire' that Swallow admires in field recordings of American folk-music, where 'stories are retold beautifully by so many different people in totally different style'. The theme of compressed time, such a force in his art, is therefore imbedded in these works at the very level of technique. It seems almost superfluous to point out that this idea of the artist as a reteller, someone who freshly speaks old formats (and, perhaps, is spoken by them), offers a generous alternative to old, modernist notions of the artist as a self-righteous enemy of convention. Along with contemporaries such as Erick Swenson and Steven Gontarski (whose work Swallow included alongside his own in his 2003 curatorial outing, *Roll Out*), and many other contemporary artists besides, Swallow has approached genre formats and seemingly anachronistic conventions as things to be learned, particularised, newly haunted, and put to use now. This gives the sculptures their special mixture of intimacy and reach. They seem public and personal, his and everyone's, in the way a good song (or a good skull) can be.

At any rate, a maker's curiosity drives the work: a wish to know at first-hand what's inside the solid, and to lure viewers in there too. In a move much favoured by the Baroque sculptors he admires, Swallow represents things with such voluptuous precision that the hand wants to check what the eye tells it. Few sculptures present so strong a challenge to the first commandment of art gallery encounter: thou shalt not touch. *Tokyo Hand* (2003) is a carving of a skeleton glove that Swallow purchased in

Tokyo in 2002. A companion piece to *Everything is Nothing* (an accessory to the crime, we might say), it likewise locates the ghost of a sculptural tradition in contemporary street wear; Swallow was thinking of reliquaries, the ornate wooden boxes that hold the bones (often the hand bones) of saints. Here, however, the bones have moved from inside to outside in the form of an immaculate inlay of epoxy putty. Recast in wood, the glove becomes a coffin for the hand it once covered, which is also the hand that carved the piece.

What gives the wooden sculptures their unusual density is the perfect fit – not a splinter to spare – between what they depict and what they are. These sculptures of remains are themselves remains; they show what is left of the body in what is left of the wood. This sounds grim, and the morbid mood seems confirmed, in a work such as *Everything is Nothing*, by the symbolism of the skull and by its title, which is taken from Antonio de Pereda's *Allegory of Transience*, c.1640. But a longer look at the object reminds us of an interesting truth, which is that a good work of art will almost always outsmart its own symbolism. In Swallow's expeditions into the still-life tradition, the *vanitas* message is constantly undercut and overridden by the formal life of the sculptures – by their exhilarated reversals of inside and outside, their summoning of the soft in the hard. 'Realism' isn't the right term here; nor do 'hyper-realism' or 'magic realism' serve. To do justice to Swallow's intensified objects, we need to reach again for a classic paradox: he wants to make a still life, and render it stiller and livelier. In their sheer sensory impact, his skull and glove do what the best still lifes do (and it is one of art's best revenges against the future). They slow ordinary objects down and give us a chance – here, now, this very hour – to come to our senses.

AT THE TIME OF WRITING

'What does the future hold for Swallow?' We would have to rule that question out of order, if the grinning skull in *Everything is Nothing* hadn't done so already. Foolish to make predictions about Swallow's career, partly because the work, though constant, continues to intensify in unexpected ways, and shows no sign of ceasing to; and mostly because the work itself – look again at that wooden grin – offers a wry and definitive commentary on the absurdity of our bids for permanence.

To survey all the objects that Swallow has made in less than a decade is to be conscious of a furious pace of making. A famous seventeenth-century book about painting exhorts artists to 'Give time your time';[10] Swallow has worked to that rule from the start. In the sculptures of 2003, though, something shifts. There's a deceleration and intensification, as if he were moving at half the pace but on an incline more than twice as steep. 'Now I think it's what you choose not to make that makes you a better artist',[11] Swallow says, and the belief is evident, numerically, in his last four solo exhibitions: five works in *Wooden Problem*, four in *Tomorrow in Common*, two in *Field Recordings*, one in *Killing Time*. A word less vague than 'exhibition' is needed to describe these shows. 'Arrangement' comes closer to conveying their increasingly bare, twanging acoustics. 'It's like with each exhibition there's an instrument being cut out of the band.'

Those who thought they had Swallow pegged as a reanimator of late capitalism's discards – a producer of fossilized boys' toys for the entertainment classes – have had to think again in the presence of the new sculptures, which are likelier to be filed under 'folk' than 'techno'. 'There's a kind of "dude art" trap to be avoided', Swallow said in 2003 when asked about the dangers of typecasting; his shift in 2002 to Los Angeles was partly to shake off such expectations. It's tempting to say that the recent works are 'warmer', but this isn't quite right, because the strength of Swallow's work has always been its willingness to disrespect the tedious distinction between hot ('expressive') and cold ('analytical') modes of art-making – to show how much heat a cold object can contain. (This is the artist who has approvingly quoted Kraftwerk on the need to seek 'feeling, but cold feeling'.) Perhaps it's enough to say that the works are uncannily patient and receptive.

This is the space into which Swallow's 2003 carving of a cactus, *Field Recording /Highland Park Hydra*, weirdly grows. With their satellite dish panels and double-jointed forms, prickly pear cacti must be some of the wrongest-looking plants on the planet (imagine a tree designed by Hans Bellmer). They sprout like Surrealist weeds in the yards and vacant lots of the suburb of Highland Park in Los Angeles, where Swallow has lived since 2002. Where most of the wooden sculptures have been dense, solid, drawn to the floor, *Field Recording/Highland Park Hydra* seems less like a thing in space than a cradle for the space flowing through it. It also has one of the largest

Facing page:
Tokyo Hand 2003
laminated jelutong, milliputt
22 x 8 x 4.5 cm
Collection of James and
Jacqui Erskine, Sydney

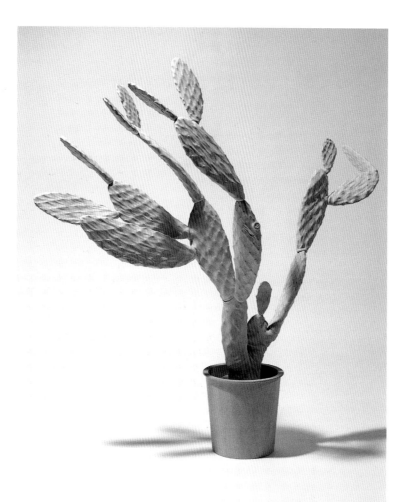

Field Recording/Highland Park Hydra 2003
laminated jelutong, steel
80 x 70 x 105 cm

Facing page:
Field Recording/Highland Park Hydra, detail 2003
laminated jelutong, steel

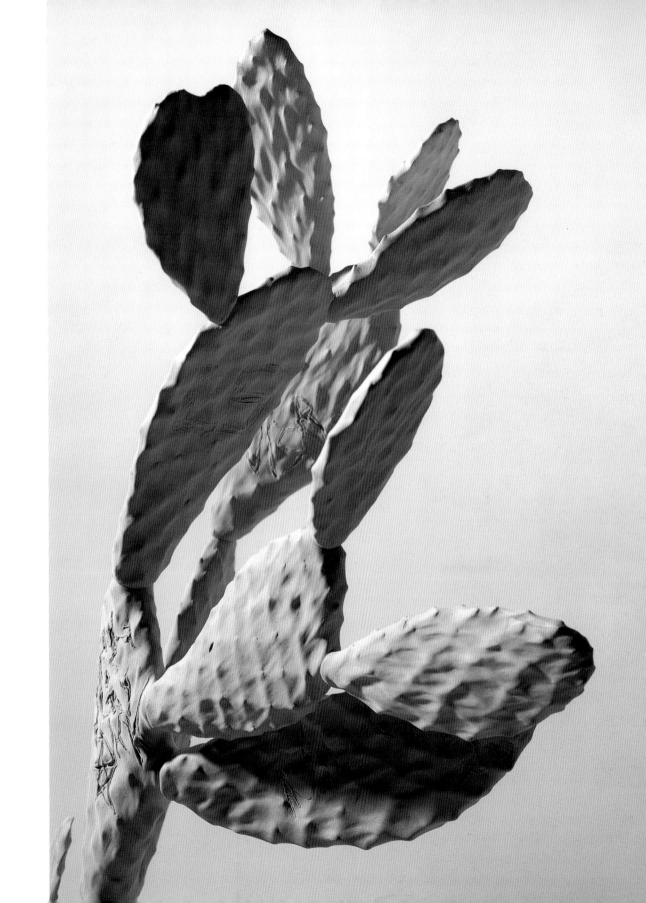

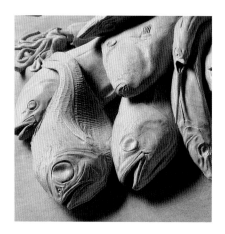

Above:
Killing Time, details 2003–2004

surface areas Swallow has carved, and its nodes and textures are as raptly drawn as a sea by Vija Celmins. Or they were, until he vandalized them. For what you see as you move around the sculpture's swaying forms are half-healed slashes and gouges of folk graffiti ('Creep', 'LS'), which Swallow sampled with his camera while out walking in Highland Park.

What is a carving? One answer: a tortured tree. Though planted firmly in the city of Los Angeles, *Field Recording/Highland Park Hydra* is emphatically haunted by a history of wood-carvings that includes Renaissance *transi* figures and, above all, the limewood crucifixions carved by German sculptors of the late Middle Ages.[12] At the same time, it calls on an unofficial sculptural history: all those harsh words and unsung names scratched into statues, all those unlicensed acts of carving. From the pristinely milled pot to the dry cicatrices, the whole sculpture opens upward in a study of every kind and speed of cut. Looking, you see the time it took the vandal to make each cut (seconds); the time it took Swallow to replicate each of those molten-looking gouges (days); the time it took for each wound to heal (months); the time it took for the wood itself to grow (years).

It can seem, at first encounter, a macabre spectacle. But the title beautifully amplifies something in the carving's body language that we may have overlooked at first. *Field Recording*. It gives us an image of the cactus as a sculptural receiver, a fleshy microphone or listening post, planted in the city and reaching up and out to absorb each word that passers-by give it. So the studio is also a recording studio, and the sculptor, out wandering in Highland Park, is also a collector. A lovely reversal now overtakes the sculpture. What had looked like damage done begins to look like an act of secret acceptance and recovery. What was taken away from the sculpture starts to look like an odd sort of donation. Like the mythic hydra, a monster that sprouted fresh heads as fast as Hercules slashed them back, Swallow's cactus seems to endure and grow outward despite – or even because of – what's been taken from it. Its catalogue of losses, to steal a line from Adam Phillips, is a record also of survival.

'Survival despite near obsolescence seems to be a theme here', Swallow said in late 2003. He was describing the faded objects and surfaces of Los Angeles, but might have been talking about the survival of sculpture, here in the early twenty-first century. A carving of something that has itself been carved, *Field Recording* insists firmly enough

on its own material paradoxes to be taken as a carving *about* carving too, a parable of sculptural stamina and endurance – and, perhaps, of other kinds of endurance. So often, in earlier work, Swallow suspended his chosen objects between a lost past and an uncertain future. He seemed to want to take them out of time. But this sculpture seems neither to regret time's passing nor to long for its arrival but to be *in* it, calmly and alertly.

Where once he measured 'his time' against the time of products, of late Swallow has found a measure in forms with looser dates, longer life-spans. Skull, fish, cactus: these are forms that have been in process for millennia. Turning attention from the friction-less surfaces of technology to the complex skins and vivid structures of flora and fauna, Swallow seems to be evolving subtler sculptural codes for light and texture, finer mergers of hard and soft – cannier ways to trap time on the surfaces of his sculp-tures. In process at the time of writing is a sculpture of a table laid with fish, mussels, squid, crayfish, the whole catch emerging from one solid, and to be named *Killing Time*. Swallow's largest reckoning with the paradoxes of still life, and in particular with the marine banquets of the seventeenth century, *Killing Time* is also a kind of memory sculpture, a wooden chronicle, in which every object trails a secret line of autobiography.[13] The creatures represent every creature that Swallow (the fisher-man's son) can remember catching, and the table they rest on is a carving of the wooden table that stood until recently in Swallow's family home – 'the place of pause and growth'. When *Killing Time* is finished, and viewers lean in and peer at its spill of shapes and memories, they'll witness a kind of triple-exposure: the time of still life, stretching back to the seventeenth century; the time of Swallow's life, from his earli-est catches onward; and finally, crucially, the time it took him to make the object. In a beautiful compression of now and then, the table where Swallow sits down daily to carve will become the carving.

But again we are getting ahead of the story. In art, perhaps in other places too, it can seem that all our energies are spent on recollections or predictions, nostalgias or futures. It can seem that we've forgotten the here and now. The beauty and mys-tery of Swallow's sculptures is the way they accept all their losses – all those studio hours, all those cuts and woodchips – and return them to us, like strange gifts, in an intensified present.

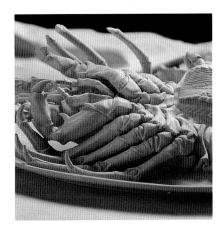

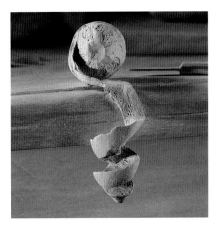

Above:
Killing Time, details 2003–2004

Following pages:
Killing Time 2003–2004
laminated jelutong, maple
108 x 184 x 118 cm (irregular)
Purchased with funds provided by the Rudy Komon Memorial Fund 2004. Art Gallery of New South Wales Collection, Sydney

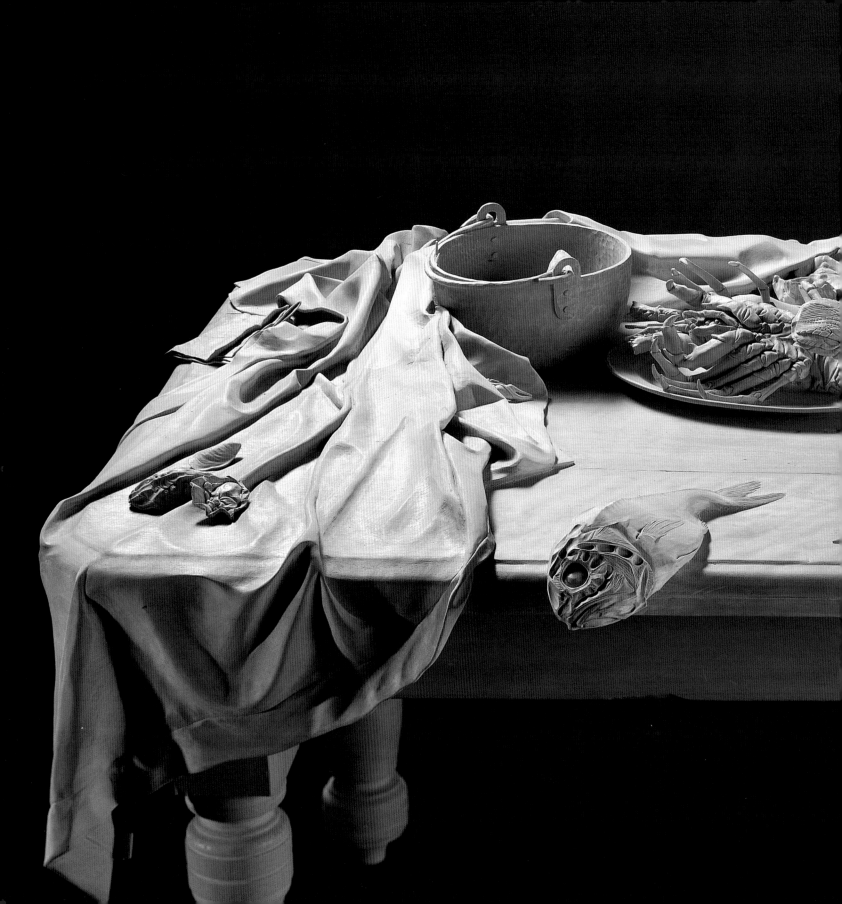

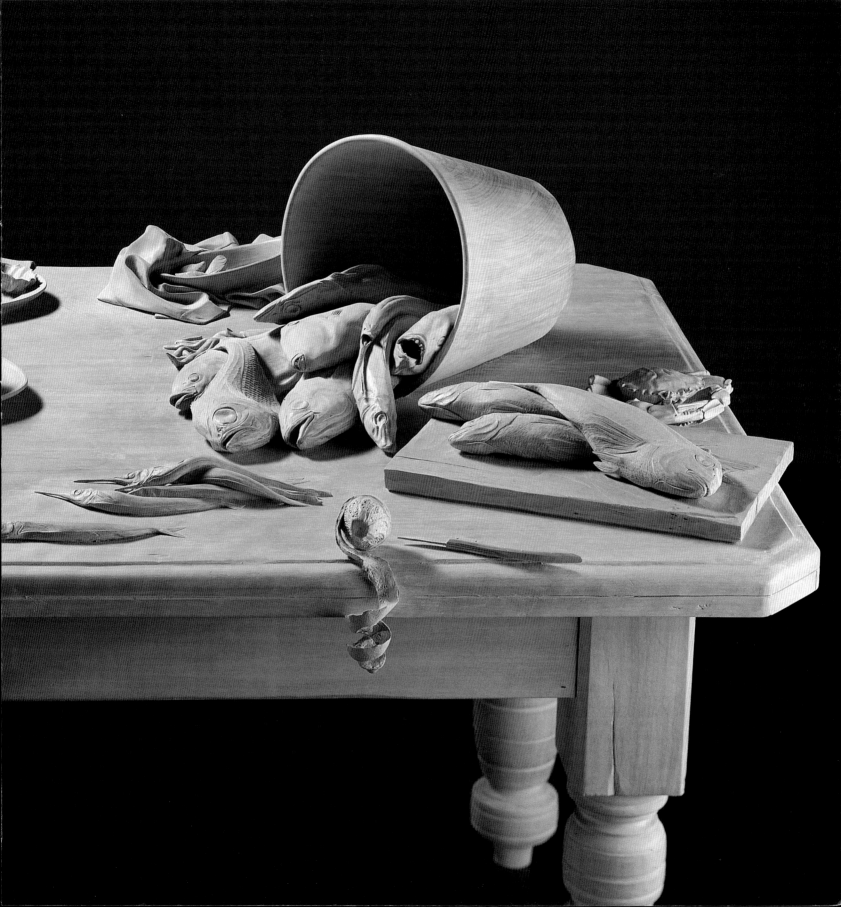

Footnotes:

1 Unless otherwise noted, all quotations are from email correspondence between the artist and author. These have been edited slightly. Sections of the text related to the exhibitions *Above Ground Sculpture* and *Wooden Problem* reproduce parts of earlier essays by the author. The essays are 'The Recreation Room', in *Ricky Swallow: Above Ground Sculpture*, Dunedin Public Art Gallery, 2001, and 'The Was and May: Ricky Swallow's *Wooden Problem*', in *Art Monthly Australia*, no. 157, March 2003, pp. 3–6.

2 From Ricky Swallow, 'Words from a vacated studio', unpublished notes, 2001.

3 Quoted in Andrew Frost, 'Memory made plastic', *Monument*, no. 33, 1999–2000, p. 103.

4 From Ricky Swallow, 'Words from a vacated studio', unpublished notes, 2001.

5 John Welchman, *Invisible Colors: A Visual History of Titles*, Yale University Press, New Haven, 1997.

6 See *Raymond Pettibon*, Phaidon, London, 2001, p. 32.

7 Quoted in Brian Duong, 'Ghost in the shell', *Silver Limbo*, 2003, pp. 136–7.

8 David Berman, from the poem 'Tableau Through Shattered Monocle', in *Actual Air*, Open City Books, New York, 1999.

9 Los Angeles has the right kind of cultural history for an artist serious about finish. Along with a wider cultural menu of etched fenders and skateboard deck designs (Swallow cites Vernon Courtland Johnson's graphics for Powell Peralta skateboards as formative), certain works by the West Coast 'fetish finish' artists seem apt historical company for Swallow, particularly Robert Irwin's tirelessly hand-polished paintings of the 1960s.

10 Karel van Mander, from his *Schilder-Boeck* (Book of Painters) of 1604. Quoted in *Still-Life Paintings from the Netherlands 1550–1720*, by Alan Chong, Wouter Kloek et al., Rijksmuseum, Amsterdam and Cleveland Art Museum, 1999, p. 81.

11 Quoted in Georgina Safe, 'Master of the Universe', *The Weekend Australian*, 28–29 Dec. 2002, p. 15.

12 Two further sources for *Field Recording/Highland Park Hydra* deserve mention. First, the carving of a cactus-like plant that clings to one travertine face of Bernini's *Fountain of the Four Rivers* in Rome. Second, the wall-hugging cascades of blossoms, fruit, fish and birds carved by Grinling Gibbons (1648–1721). Michael Baxandall's *The Limewood Sculptors of Renaissance Germany* (Yale University Press, New Haven, 1980) has been an important image-bank.

13 *Killing Time* also recoups a moment in Australian art history. The earliest known Australian oil painting is a marine still life, John Lewin's *Fish Catch and Dawes Point, Sydney Harbour*, c. 1813, from the collection of the Art Gallery of South Australia, Adelaide.

CURRICULUM VITAE

Born 1974, Australia, currently lives and works in London

Education

1997 Bachelor of Fine Art Major Drawing, Victorian College of the Arts, Melbourne

Solo Exhibitions

2004 'Killing Time', Darren Knight Gallery, Sydney, Australia
 'Killing Time', Gertrude Contemporary Art Spaces, Melbourne, Australia
2003 'Field Recordings', Project Room, Tomio Koyama Gallery, Tokyo, Japan
2002 'Tomorrow in Common', Andrea Rosen Gallery, New York, USA
 'Wooden Problem', Karyn Lovegrove Gallery, Los Angeles, USA
 'A Sculpture now', First Floor Artists and Writers Space, Melbourne, Australia
2001 'For Those Who Came in Late', Matrix 191, Berkeley Art Museum, San Francisco, USA
2000 'Above Ground Sculpture', Dunedin Public Art Gallery, Dunedin, New Zealand
 'Above Ground Sculpture', Hamish McKay Gallery, Wellington, New Zealand
 'Unplugged', Darren Knight Gallery, Sydney, Australia
 'Plastruct', Karyn Lovegrove Gallery, Los Angeles, USA
 'Individual Ape', Hot Rod Tea Room, Oslo, Norway
1999 'The Multistylus Programme', Studio 12, 200 Gertrude Street Gallery, Melbourne
1998 'Repo Man', Darren Knight Gallery, Sydney
 'The Lighter Side Of The Dark Side', Grey Area Art Space Inc, Melbourne
 'Small World', Teststrip, Auckland, New Zealand

Group Exhibitions

2004 'Living Together Is Easy', Contemporary Art Center, Art Tower Mito, Japan; National Gallery
 of Victoria, Melbourne, Australia
 'The Ten Commandments', Deutsches Hygiene-Museum, Dresden, Germany
2003–4 'Fair Game. Art + Sport', NGV Response Gallery, Melbourne, Australia
2003 'Variations on the Theme of Illusion', Emily Tsingou Gallery, London, UK
 'See Here Now: Vizard Foundation Art Collection of the 1990s', The Ian Potter Museum of Art,
 The University of Melbourne, Victoria, Australia
 'The Future in Every Direction: Joan Clemenger Endowment for Contemporary Australian
 Art', Ian Potter Centre, National Gallery of Victoria, Melbourne, Australia
 'Some Things We Like', Asprey Jacques, London, UK
 'The Fourth Sex, Adolescent Extremes', Stazione Leopolda, Florence, Italy
 'Guided By Heroes', Curated by Raf Simons, Z33, Hasselt, Belgium
 'Still Life', Art Gallery of New South Wales, Sydney, Australia
 'Art and Film', Centre for Contemporary Photography, Melbourne, Australia
 'Roll Out', Curated by Ricky Swallow, Karyn Lovegrove Gallery, Los Angeles, USA
2002–3 'Gulliver's Travels', touring exhibition, College of Fine Arts, Sydney; Monash University
 Museum of Art, Melbourne; Institute of Modern Art, Brisbane; Canberra Contemporary Art
 Space, Canberra; Contemporary Art Centre of South Australia, Adelaide and Perth Institute
 of Contemporary Art, Perth, Australia

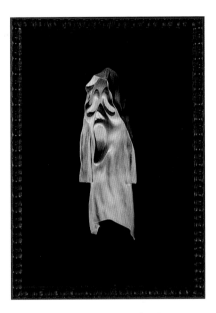

Picture a Screaming Sculpture 2003
piezo pigment print on hahnemuhle
rag paper
80 x 57 cm
Collection of Amanda Love, Sydney

2002 '1st Floor Final Exhibition', 1st Floor, Melbourne, Australia

'People, Places + Ideas, Celebrating Four Decades of the Monash University Collection', Monash University Museum of Art, Victoria, Australia

'Half The World Away', Hallwalls Contemporary Arts Center, Buffalo, USA.

'Big Bang Theory; Recent Chartwell Acquisitions', Auckland Art Gallery, New Zealand

'Remix: contemporary art & pop', Tate Liverpool, England, UK

'Extended Play, Art Remixing Music', Govett-Brewster Art Gallery, New Zealand

'Remix', Tate Liverpool, Liverpool, England

'Possible Worlds', Artspace, Auckland, New Zealand

2001 'None More Blacker', 200 Gertrude Street, Melbourne, and touring exhibition; Geelong Gallery, Shepparton Art Gallery, Victoria, Australia; Wollongong City Gallery, New South Wales, Australia; Global Arts Link, Ipswich, Queensland, Australia

'Bootylicious', Ian Potter Museum of Art, Melbourne University, Australia

'A person looks at a work of art...', Heide Museum of Modern Art, Melbourne, Australia

'Casino 2001', SMAK, Ghent, Belgium

'Good Work', Dunedin Public Art Gallery, City Gallery, Wellington, New Zealand

'Swallow/Swenson', Museum of Contemporary Art, Sydney, Australia

'Rubik 13', Sarah Cottier Gallery, Sydney, Australia

'Utopia/ROR', Kiasma Museum of Contemporary Art, Helsinki, Finland; Kiel Museum of Art, Kiel, Germany; Skulpturens Hus, Stockholm, Sweden

2000 'Keith Edmier, Ricky Swallow, Erick Swenson', Andrea Rosen Gallery, New York

'The Retrieved Object', Linden Art Gallery, Melbourne, Australia

'Are You Experienced?', The Physics Room, Christchurch, New Zealand

'Uncommon World', National Gallery of Australia, Canberra, Australia

'Spin Me Round', Metro Arts, Brisbane, Australia

'Drawn From Life', Marianne Boesky Gallery, New York, USA

'Terra Mirabilis', Centre for Visual Arts, Cardiff, Wales, UK

'Brand New Master Copy', UKS Gallery, Oslo, Norway

'Rent', Overgaden Gallery, Copenhagen, Denmark

1999 'Spellbound', Karyn Lovegrove Gallery, Los Angeles, USA

'Make It Yourself', 200 Gertrude Street Gallery, Melbourne, Australia

'Contempora 5', The Ian Potter Museum of Art, Melbourne, Australia

'Group Drawing Exhibition', Hamish McKay Gallery, Wellington, New Zealand

'Signs Of Life', Melbourne International Biennial, Melbourne, Australia

'Multiples', Ivan Anthony Gallery, Auckland, New Zealand

'Walkmen', with David Jolly and David Noonan, Synaesthesia Music, Melbourne

'Rubik 3 Video vs Watercolor', 36 Wellington St, Collingwood, Melbourne

'Misty vs City Lights 2000', City Lights, Hosier Lane, Melbourne

'Institutional Transit Lobby', 200 Gertrude Street Gallery, Melbourne

'Injection', Performance Space, Sydney, Australia

'Video Soup', Collective Gallery, Edinburgh, Scotland, UK

1998 'Taken', Curated by Jon Cattapan, R.M.I.T Project Space, Melbourne

'Hobby Core', Curated by Ricky Swallow, Stripp Gallery, Melbourne

'Beaux Arts Art in the World '98', Passage de Retz, Paris, France

'Metamorphosis', Mornington Peninsula Regional Gallery, Melbourne

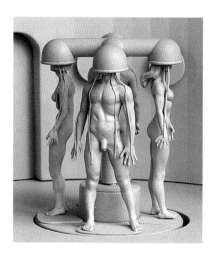

Building Better Beings, detail 2000
turntable, plastic epoxy, PVC

'All This And Heaven Too', Adelaide Biennial Exhibition, Art Gallery of South Australia

'Wild Kingdom', Institute of Modern Art, Brisbane, Australia

1997 'Ear to the Ocean', with Michael Graeve, Grey Area Art Space Inc, Melbourne

'Going Nowhere', Curated by Julia Gorman, Grey Area Art Space Inc, Melbourne

'Diorama', Curated by Charlotte Day, 200 Gertrude Street Gallery, Melbourne

'Gathering', Curated by Ricky Swallow, Platform 2, Melbourne

1996 'Before My Eyes A Bedroom Monster', Stop 22 Gallery, Melbourne

Selected Bibliography

2003 Paton, Justin, 'The Was and May', *Art Monthly Australia*, March 2003

2002 Crawford, Ashley, 'A person looks at a work of art...', The Buxton Contemporary Australian Art Collection, catalogue text, Heide Museum of Modern Art

Johnson, Ken, *Art in Review*, *The New York Times*, Friday September 20, 2002

Myers, R. Terry, 'Wooden Problem', review, *Contemporary*, September 2002

Spiderland, Artist pages, *1,2,3,4*, Issue 3, Sydney, Australia

Safe, Georgina, 'Master of the Universe', *The Weekend Australian*, December 28–29, 2002

Wallis, Simon, *Remix* catalogue, Tate Liverpool, Artist' Entries

2001 Artist Pages, Casino 2001 catalogue

Braye, Marah, 'The Voyeur Awakes', *Art and Australia*, April 2001

Gawronski, Alex, 'A sum and its parts', Rubik @ Sarah Cottier, review, *Eyeline*, Spring 2001, Issue 46, Australia

Kent, Rachel, 'Classical Contemporary', Swallow/Swenson, catalogue text, MCA, Sydney, Australia

Palmer, Daniel, 'Shadow Play', *Frieze*, Issue 58, UK

Paton, Justin, 'The Recreation Room', catalogue text, Above Ground Sculpture, Dunedin Public Art Gallery, Dunedin, New Zealand, 2001

Travis, Lara, 'None More Blacker', catalogue text, 200 Gertrude Street Gallery, Australia

Zoo, September, 2001, Artist profile, London, England

Zuckerman Jacobson, Heidi, 'Ricky Swallow', Matrix gallery brochure, Berkeley 2001

2000 Brennan, Stella, 'Economies of Scale', plus Artist Page, *Pavement Magazine*, Issue 44, NZ

Fenner, Felicity, 'New Life In Melbourne', *Art in America*, January

James, Bruce, 'Odd Birds in Swallows Nest', *The Sydney Morning Herald*, 4 November 2000

Koestenbaum, Wayne, 9, Commodity Fetishism in Sculpture, *Artforum*, best of 2000

Koop, Stuart, 'Rent Art', notes on the works, *Ojeblikket*, Special Issue 3

Krister, Bo, 'Brand New Master Copy', catalogue intro, UKS Gallery, Oslo, Norway

Pestorius, David, 'Spin Me Round', catalogue text, Metro Arts, Brisbane, Australia

Preview, 'Rent', Australian Centre for Contemporary Art, *Contemporary Visual Arts*, 29

Tonkin, Steven, 'Uncommon World', catalogue text, NGA, Canberra, Australia

Walaker, Jan, 'Monkey Business', interview and artist pages, *Hot Rod* Issue 6, Oslo, Norway

1999 Chapman, Chris, 'Space 1999, Quick Responses', 1999 Melbourne International Biennial, May 1999

Clabburn, Anna, 'Plentiful Life Signs', *The Age*, 9th June 1999, Melbourne

Colless, Edward, 'The World Ends When Its Parts Wear Out', Memory Made Plastic, Ricky Swallow 1999

Frost, Andrew, 'Ricky Swallow', *Monument*, Issue 33 1999

Earth Time / Ship Time 2001
watercolour on paper
28 x 38 cm

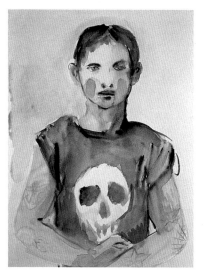

Tattooed Boy No. 1 2002
watercolour on paper
38 x 28 cm
Collection of Michael Benevento, New York

Nicholson, Tom, 'Signs of Life', Melbourne International Biennial review, *Art & Australia*, vol. 37 1999

Nicholson, Tom, 'Contempora 5' catalogue text, Ian Potter Museum of Art, Melbourne

O'Connell, Stephen, 'Repo Man', review, *Like* art magazine, Issue 7 summer 1998–99

Palmer, Daniel, 'Hobby Core', review, *Like* art magazine, Issue 7 summer 1998–99

Palmer, Daniel, 'Melbourne International Biennial', review, *Frieze*, no. 48 September 1999

Palmer, Daniel, 'Walkmen', review, *Frieze*, no. 46 May 1999

Rooney, Robert, 'Show Them The Money', Review, *The Weekend Australian*, 25 September 1999

Rooney, Robert, 'A little chaos, but definite life signs', *The Australian*, 21 May 1999

1998 Hjorth, Larissa, 'Hobby Core', *Log Magazine*, Christchurch, New Zealand, September 1998

Smee, Sebastion, 'Are we not men?', *Sydney Morning Herald*, 18 September 1998

Engberg, Juliana, 'No Radio', *Art and Text*, August–October 1998

Koop, Stuart, 'Diorama', 200 Gertrude Street Gallery, review, *Art and Text*, January 1998

McDonald, Ewen, 'All This and Heaven Too', *Art & Australia*, vol. 36 1998

McKenzie, Robyn, 'Being and Time, the new existentialism', Beaux Arts, Art in the World 98 (catalogue edition)

McQualter, Andrew, 'All This And Heaven Too', Catalogue text, AGSA

Nicholson, Tom, 'Leagues Under the Sea', *Like* art magazine, Issue 5 March 1998

Sequeira, David, 'Cues, metaphors and dialogues', *Real Time*, August 1998

1997 Clabburn, Anna, 'Replanting Our Natural Heritage', review, *The Age*, 29 October 1997

Day, Charlotte, 'Dioramas and The Invention of Nature', catalogue text, Diorama, 200 Gertrude Street Melbourne

Huppatz, DJ, 'The Lighter Side of The Dark Side', review, *Artlink*, December 1997

McQualter, Andrew, 'Science Fiction', Ricky Swallow, *Globe E* on-line art journal, Nov. 97

Awards / Grants

2002 Australia Council International Studio Residency, London (2004)
1999 Contempora 5 Art Award
1998 Emerging Artists Grant, The Australia Council

Collections

Buxton Collection, Melbourne, Australia
Chartwell Trust, Auckland, New Zealand
John McBride Collection, Australia/Japan
Norton Family Collection, Los Angeles, USA
National Gallery of Australia, Canberra, Australia
National Gallery of Victoria, Melbourne, Australia

Representation

Darren Knight Gallery, Sydney, Australia
Hamish McKay Gallery, Wellington, New Zealand
Modern Art, London, UK